MW00610989

WAR IN THE AIR

Published by IWM, Lambeth Road, London SE1 6HZ
iwm.org.uk

© The Trustees of the Imperial War Museum, 2019

All rights reserved. No part of this publication may be reproduced,
stored in a retrieval system or transmitted, in any form or by any
means, electronic, mechanical, photocopying, recording or otherwise
without the prior permission of the copyright holder and publisher.

ISBN 978-1-912423-03-3

A catalogue record for this book is available from the British Library

Printed and bound in Italy by Printer Trento
Colour reproduction by Zebra

All images © IWM unless otherwise stated
Front cover: FRE 14185 (see page 61)
Back cover: TR 176 (see page 118)

Every effort has been made to contact all copyright holders.
The publishers will be glad to make good in future editions any error or
omissions brought to their attention.

10 9 8 7 6 5 4 3 2

FSC
www.fsc.org

MIX
Paper from
responsible sources
FSC® C015829

WAR IN THE AIR

THE SECOND WORLD WAR IN COLOUR

Ian Carter

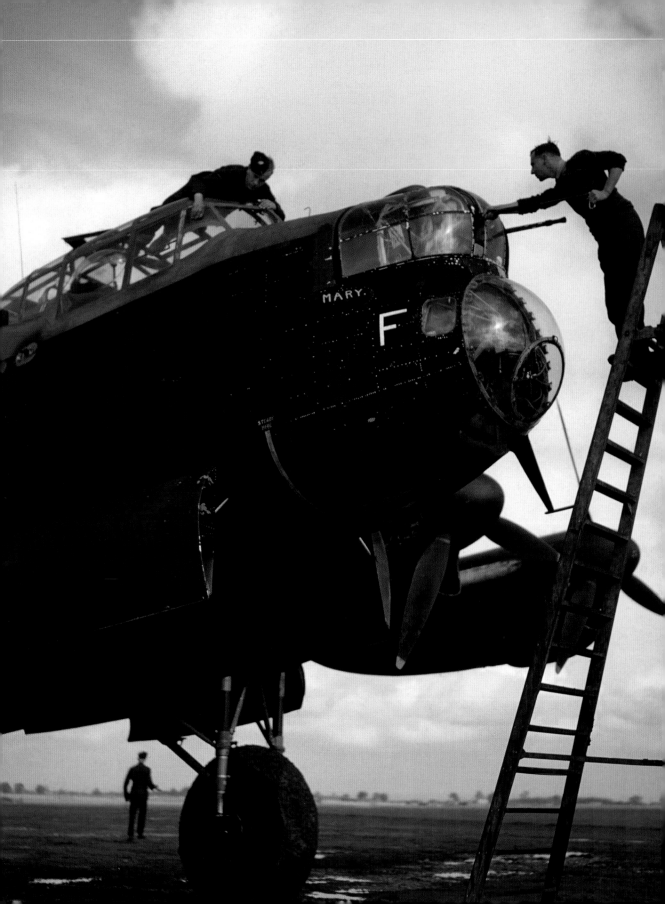

CONTENTS

INTRODUCTION — 6

CHAPTER ONE:
FIGHTER BOYS — 10

CHAPTER TWO:
BOMBER COMMAND — 26

CHAPTER THREE:
MEDITERRANEAN AIR WAR — 44

CHAPTER FOUR:
MARITIME STRIKE — 64

CHAPTER FIVE:
USAAF OVER THE REICH — 80

CHAPTER SIX:
TRAINING AND TRANSPORT — 108

IMAGE LIST — 126

ACKNOWLEDGEMENTS — 127

INTRODUCTION

Allied victory in the Second World War owed much to airpower. The Royal Air Force (RAF) and United States Army Air Forces (USAAF) played a vital role in protecting home territory from enemy attack and by supporting the military and maritime operations that led ultimately to Nazi defeat in the west. A third, more contentious aspect was the launching of a strategic bombing offensive against German industry. For some, the undermining of Germany's war economy and the morale of its population promised to bring about victory by itself. In this it failed, but the massive attrition, disruption and diversion of effort that Allied bombing caused contributed in no small way to the defeat of Hitler.

From the start of the war, the defence of Britain was paramount. Following the RAF's victory in the Battle of Britain, the threat of invasion gradually subsided, especially after Hitler's assault on the Soviet Union in 1941. German aerial attacks on the United Kingdom, which peaked during the Blitz, continued sporadically for much of the war but on a decreasing scale, as the Luftwaffe was diverted elsewhere. These later raids caused only minor damage, but nevertheless pinned down large numbers of RAF aircraft. Meanwhile, Fighter Command went on the offensive, but was initially hamstrung by aircraft not designed for the role. The Spitfire was a superb defensive fighter but lacked the endurance for effective cross-Channel operations.

Much was expected of RAF Bomber Command, which at first offered the only way to hit back at the Nazi war machine. However, expectations of early success were soon dashed as its own weaknesses and the enormity of the task were revealed. Only in 1943 did the heavy bomber force gain the means to do serious damage to German industrial cities. Its destructive capabilities increased dramatically thereafter, but at terrible cost to aircrew and German civilians alike. At sea, the U-boat was the major threat, and RAF Coastal Command evolved from small beginnings into a powerful maritime force, which co-operated effectively with the Royal Navy to protect Britain's Atlantic lifeline with the United States. Germany's own seaborne trade was stifled by aerial

attacks on its merchant shipping, while its surface warships were hounded to destruction or forced to lie low in home ports, always threatened by aerial bombing.

The supply of aircraft and trained crews was a major preoccupation for those fighting on other fronts too. Axis offensives in the Mediterranean in 1940 and 1941 required the diversion of significant British forces, and the transfer of squadrons from home defence. The security of Egypt and the Suez Canal, and the Royal Navy's dominance in this theatre, had to be preserved at all costs. Greece and Crete fell, but Malta held out after an epic struggle, with RAF and Royal Navy squadrons contributing to the valiant defence of the island and the convoys supplying it. The Desert Air Force, living a nomadic existence in the wastes of North Africa, developed the skills required for effective cooperation with the army. In late 1942, USAAF squadrons joined those of Britain fighting the retreating Germans in Tunisia. By this date, Allied numerical strength was beginning to count and the Axis air forces found themselves increasingly squeezed. Anglo-American strategy remained focused on the Mediterranean throughout 1943, with successful invasions of Sicily and Italy both facilitated by wide-ranging air support.

America was responsible for a decisive increase in Allied airpower. Once its industries were harnessed for the war effort there would be no shortage of aircraft (almost 300,000 were eventually produced), and many were supplied to the RAF and Fleet Air Arm (FAA). Early on, the Allies decided on a 'Germany First' policy, so that while the US Navy would bear the burden of operations in the Pacific, the US Army would concentrate its efforts in Europe, using Britain as a springboard. An army would be built in readiness for an invasion of France, and a strategic bombing force deployed for operations over the Reich. Unwilling to join RAF Bomber Command's night offensive against German cities, the US Eighth Air Force (and later the Fifteenth, operating from Italy) embarked on precision daylight attacks on key enemy industries. Its B-17 Flying Fortress and B-24 Liberator bombers suffered heavy casualties at first, but the advent of long-range escort fighters, and a steady increase in numbers, turned the tide. In 1944, the Luftwaffe, suffering unsustainable losses, lost control of its own airspace.

In the last year of the war, Allied qualitative and quantitative superiority became overwhelming. Control of the air was a vital pre-condition for Operation 'Overlord', and contributed massively to the success of that great enterprise. The fighters and medium bombers of the tactical air forces,

set up to cooperate with British and American Armies in Europe after D-Day, provided valuable assistance over the battlefront and far behind the lines, so that German troops were regularly shot up, pinned down and starved of supplies and reinforcements. Transport squadrons performed the unglamorous but vital role of moving men and materiel, and took part in mass airborne operations over Normandy, the Netherlands and the Rhine. The RAF and USAAF heavy bomber forces, hitherto following separate strategic paths, finally combined their efforts in attacks on the enemy's fuel supplies and transport infrastructure. Civil and military defence against the bombing onslaught consumed huge resources of German manpower, weapons and ammunition. Extensive damage was done to German industry, much of it indirectly by forcing the dispersal of production and the laborious construction of underground facilities.

Technology grew apace during the war years, and there were quantum leaps in aircraft design and capabilities. The Lancaster gave RAF Bomber Command the means to haul vast tonnages of explosives and incendiaries far into Germany, dwarfing the lifting power of early bombers. The Mosquito was such an inspired design that it served in a multitude of roles spanning all RAF Commands, and was also used by the USAAF. The P-51 Mustang, a perfect marriage between American airframe and British engine, could cross a continent to a distant target and outperform the opposition when it got there. There were dramatic developments in radio navigation systems and radar. Darkness no longer protected cities from attack, nor indeed the attackers themselves, and the surfaced U-boat, seemingly safe on a dark, empty ocean, was now vulnerable to sudden, catastrophic attack from the air.

This book presents a selection of original colour photographs of the aircraft and men involved in these battles. Colour photography was a rarity during the Second World War, and the subjects covered here have been dictated by the availability of images held in the IWM archives. There are official British photos, chosen from a small but significant collection collated by the wartime Ministry of Information, and examples from American sources. We are fortunate that American servicemen had much greater access to colour Kodachrome film, which originated in the United States in 1936 and was used for the vast majority of the images seen here. These constraints mean that the book concerns itself mostly with the British, Commonwealth and US air forces in Europe and the Mediterranean. All the images have been carefully optimised to restore colour accuracy and clarity.

While the aircraft and hardware of the Allied air war are graphically illustrated in this volume, less easy to discern is the human cost. Some of the men glimpsed here would not survive. RAF Bomber Command alone lost nearly 56,000 men, almost half of all those who served, and an estimated 30,000 men from the US Army Air Forces were killed in action in the European Theatre of Operations (ETO). There were times, especially early on, when their sacrifice seemed in vain. However, unlike Germany, Britain and the United States were committed to a long-term and comprehensive air strategy, encompassing independent bombing offensives, close cooperation with naval forces and tactical support for the armies on the ground. The plan was to minimise the battlefield blood-letting that had characterised the First World War. It benefitted from a substantial economic base, fortuitous production decisions and a huge investment in training. All these factors ensured eventual success, as evidenced in the final year of the war when Allied aircraft swarmed at will over Germany and occupied Europe. Allied victory was undoubtedly a combined arms effort, but dominance in the air was perhaps the key determinant.

(Page 4)
Ground staff clean the nose machine guns and cockpit glazing of Avro Lancaster B Mk I R5666 'KM-F' at Waddington, October 1942. The Lancaster was the RAF's principal heavy bomber during the second half of the war, and the main instrument of Bomber Command's night offensive against German industry. It could carry up to 14,000lbs of high explosive bombs and incendiaries. This aircraft was one of three from 44 Squadron shot down on the night of 17–18 December 1942 during a raid on Nienburg in northern Germany.

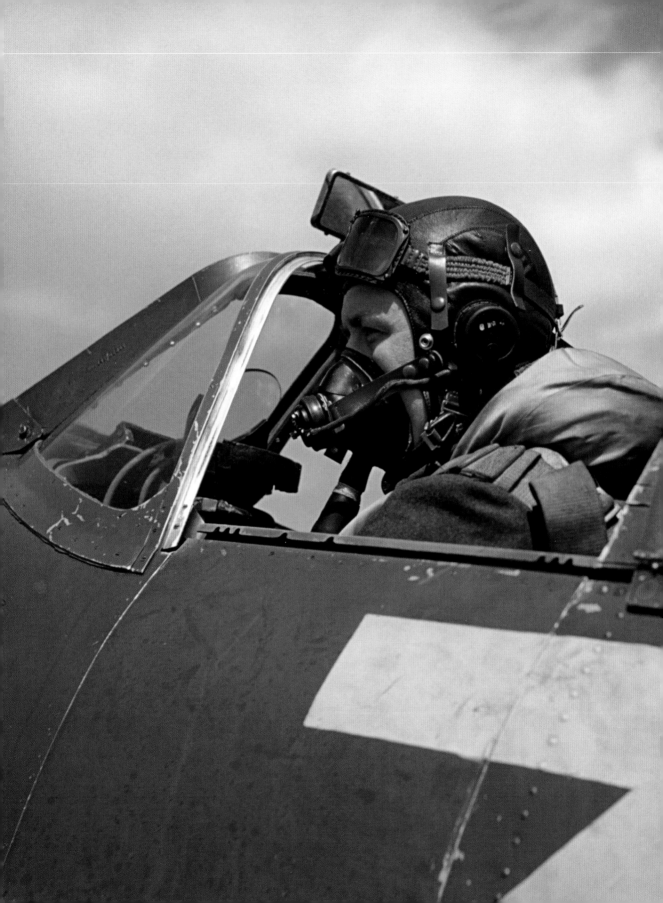

CHAPTER ONE

FIGHTER BOYS

In the summer of 1940, RAF Fighter Command inflicted a major defeat on the Luftwaffe. German failure to gain air superiority during the Battle of Britain helped persuade Hitler to abandon his plan to invade Britain and instead concentrate his armies for an invasion of the Soviet Union. The Luftwaffe began a night bombing campaign against British cities and ports, hoping to weaken British resolve and disrupt vital imports. London suffered an intensive series of raids between September 1940 and May 1941, which became known as the Blitz.

The RAF's nocturnal defences were weak at first, but the advent of new radar systems and Beaufighter night-fighters had a marked effect and by the spring of 1941 German bombers were suffering increasing losses. The raids tailed off in May as Luftwaffe units were deployed east, but the RAF had to maintain its guard. The threat of invasion – and another Battle of Britain – could not be discounted. Many new fighter squadrons were formed, with the Spitfire the most numerous type. Fighter Command now switched to the offensive, carrying out ground attack missions and sweeps over enemy territory. The aim was to tempt the Luftwaffe into battle, sometimes using bombers as bait. The pressure to divert enemy squadrons increased after Hitler's assault on the Soviet Union, but RAF fighters lacked the range to penetrate far inland and the new German Focke-Wulf Fw 190 was superior to the Spitfire Mk V. Some 300 RAF pilots were lost for little or no gain during the so-called 'summer offensive'.

In the spring of 1942, the Mosquito entered service with Fighter Command's night-fighter squadrons, helping to defend against a spate of retaliatory bombing attacks on historic and less well-defended cities. These so-called *Baedeker* raids caused minimal damage and German losses were high. The Luftwaffe renewed its offensive in January 1943, carrying out the first big attack on London since May 1941. Again, the RAF exacted a heavy

toll. Incursions by Luftwaffe fighter-bombers were harder to deal with. Fw 190 'Jabos' (an abbreviation of *Jagdbomber*) flew 'tip and run' raids against seaside towns, coming in low and fast to avoid interception. Large-scale fighter-bomber attacks were mounted against Canterbury in October 1942 and London in the spring of 1943, but the effects of these operations were negligible and RAF countermeasures made them unsustainable. New Typhoon and Spitfire Mk XII fighters had the speed to overhaul the invaders at low level, and Mosquitoes could pick them off at night.

Fighter Command's own losses mounted as the RAF's cross-Channel offensive continued. The new Spitfire Mk IX was rushed into production to combat the Fw 190. Four squadrons were equipped by August 1942 in time for a large-scale aerial battle fought in support of the combined operations raid on Dieppe. In a day of intensive combat, the RAF lost 98 fighters in exchange for only 48 enemy aircraft. Despite improvements, the Spitfire's lack of range was a major challenge, especially now that bomber escort duties were becoming an increasingly important part of Fighter Command's work. This had major repercussions for the American Eighth Air Force, now beginning attacks on targets well beyond RAF fighter cover. The Mosquito, however, was well suited to an offensive role. Its speed, range and formidable armament made it ideal for long-distance missions over enemy territory, hunting enemy aircraft and striking ground targets.

In late 1943, as the Allies prepared for the invasion of Europe, RAF Fighter Command was reorganised. Over half its squadrons were transferred to the newly created 2nd Tactical Air Force (2 TAF), which would provide air support for British and Canadian Armies on the continent. Meanwhile, the Luftwaffe had gathered a force of around 500 bombers, and in January 1944 launched another series of attacks against London and other cities codenamed Operation 'Steinbock' and known as the 'Baby Blitz'. As ever, Hitler was more interested in retaliation against the civil population than hitting military targets. The assault lasted until May, but caused only minor damage. At least 300 Luftwaffe aircraft were shot down.

This was the last major attack on Britain by conventional aircraft. It ended shortly before the Allies stormed ashore in Normandy on 6 June 1944. RAF fighter squadrons helped provide aerial protection for the armada of warships and landing craft on D-Day, and for the army once ashore. Typhoons armed with rockets and bombs established a fearsome reputation, wreaking havoc on German tanks and transport. In the same month, a new threat materialised

when the first of Hitler's pilotless V-1 flying bombs were launched against London. The fastest Allied aircraft – Spitfire Mk XIVs, Tempests and Mustangs – were deployed to meet them. By September, when the attacks subsided, RAF fighters had shot down 1,771 of these 'doodlebugs'.

By now there was little aerial opposition over Britain, and for the remainder of the war the main task of the RAF's home-based fighter squadrons was to provide escort for bombers and anti-shipping aircraft. To this end, increasing numbers of squadrons swapped their Spitfires for American-built Mustangs, able to fly much longer missions. Meanwhile, 2nd Tactical Air Force, operating from a succession of captured airfields, maintained its vital support role for British ground forces as they advanced inexorably into Belgium, the Netherlands and, finally, Germany.

(Previous Page)
Flight Lieutenant Walter Laurie of 222 Squadron in the cockpit of his Spitfire Mk VB at North Weald in Essex, May 1942. He wears typical flying kit of the time – a Type C leather helmet, Mk III goggles and Type E black rubber oxygen mask. 'Feathers' Laurie later joined 610 Squadron, taking command of the squadron in May 1943. In 1944, he was posted to the staff of the new Fighter Leaders School at Milfield in Northumberland, set up to teach the air support tactics necessary for the invasion of Europe.

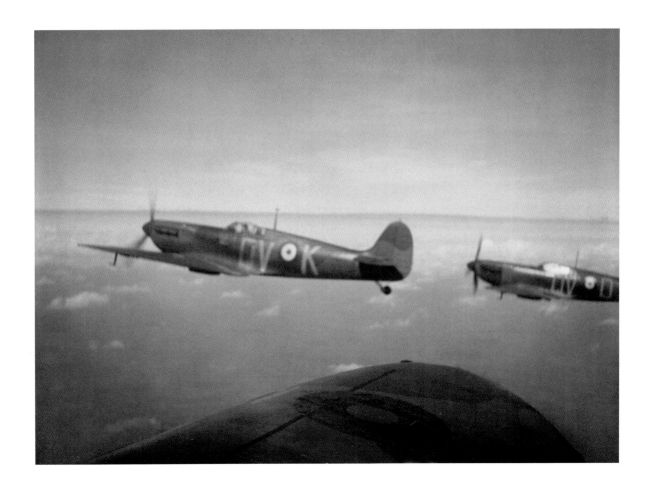

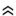

Supermarine Spitfire Mk Is of 19 Squadron in early 1940. Based at Duxford in Cambridgeshire, 19 Squadron was the first to be equipped with the iconic fighter. This unique image was taken on Dufaycolor film by Pilot Officer Michael Lyne. Dufaycolor was an early British film stock, cheaper but less sophisticated than the American Kodachrome. Lyne was badly wounded in the knee over Dunkirk in May 1940, when the squadron was operating from Hornchurch, but returned to operations a year later and survived the war, eventually retiring as an Air Vice-Marshal in 1971.

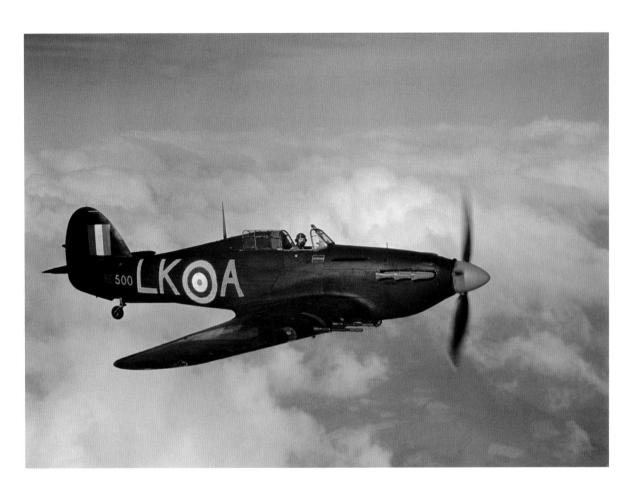

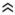

Hawker Hurricane Mk IIC BE500 being flown by Squadron Leader Denis 'Splinters' Smallwood, the Commanding Officer of 87 Squadron, based at Charmy Down near Bath, May 1942. The Hurricane could no longer compete with the latest German fighters, and had been relegated to night fighting and ground attack operations. The Mk IIC was powerfully armed with four 20mm Hispano cannon, while other versions could carry bombs. As well as air defence duties, 87 Squadron flew night 'intruder' sorties over occupied France, shooting up airfields, transport and other targets of opportunity. The aircraft is painted in the overall black 'Special Night' scheme used by Fighter Command for night operations during this period.

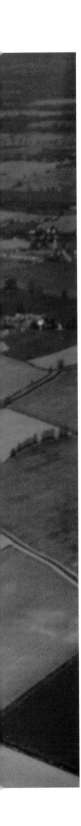

«

**Spitfire Mk VB AD233 *West Borneo I* being flown
by the Commanding Officer of 222 Squadron,
Squadron Leader Richard Milne, May 1942.** 'Dickie'
Milne was rested from operations later that month.
His replacement, Squadron Leader Jerzy Jankiewicz,
was killed in this aircraft soon after, when it was shot
down by an Fw 190 on a sweep to Ostend on 25 May.
Milne went on to command the Biggin Hill Wing in
1943, but was also shot down in March that year and
spent the rest of the war in a prisoner of war camp.
He was credited with 15 aerial victories.

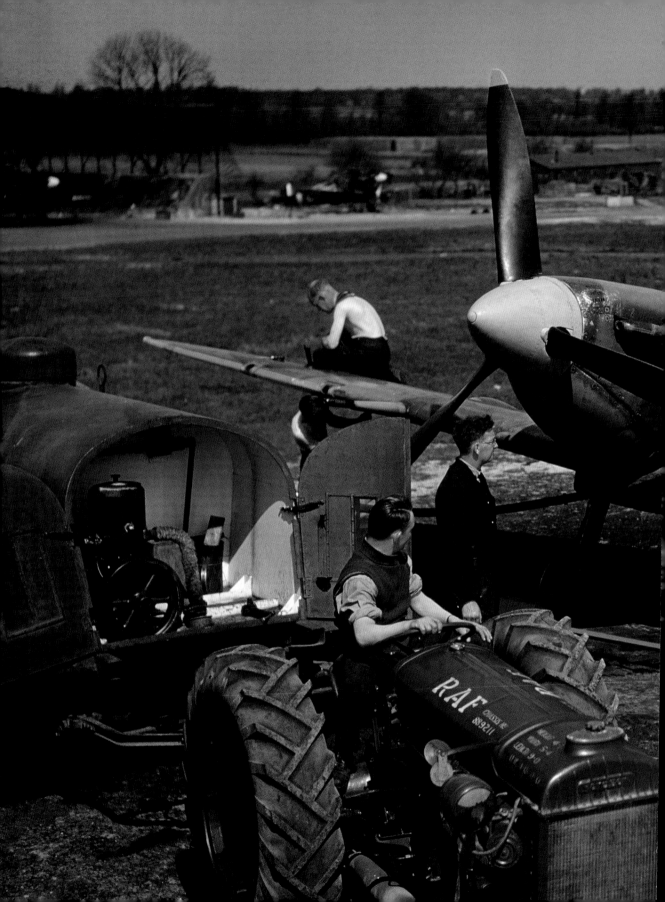

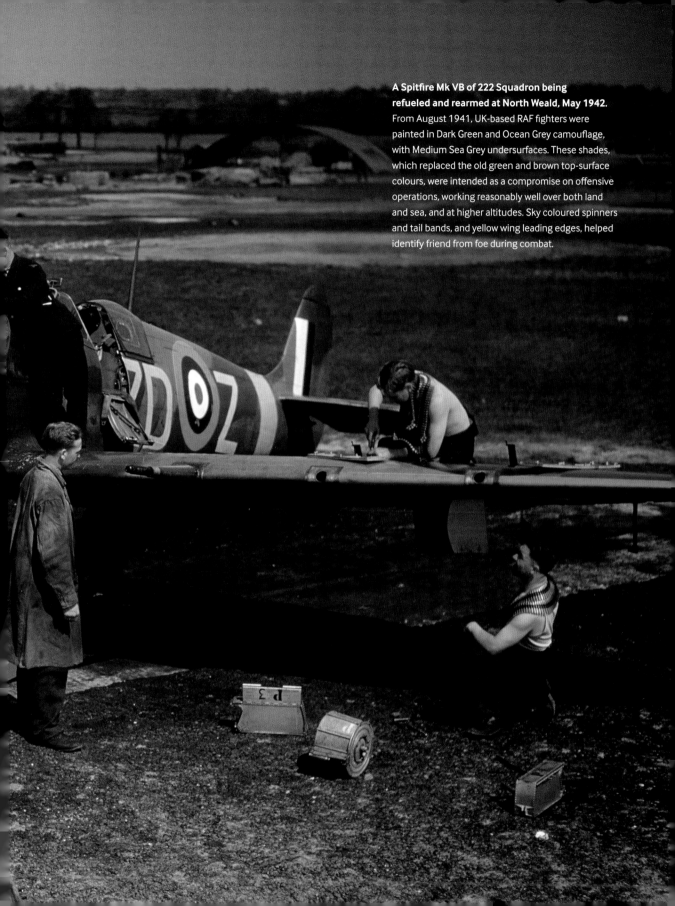

A Spitfire Mk VB of 222 Squadron being refueled and rearmed at North Weald, May 1942. From August 1941, UK-based RAF fighters were painted in Dark Green and Ocean Grey camouflage, with Medium Sea Grey undersurfaces. These shades, which replaced the old green and brown top-surface colours, were intended as a compromise on offensive operations, working reasonably well over both land and sea, and at higher altitudes. Sky coloured spinners and tail bands, and yellow wing leading edges, helped identify friend from foe during combat.

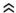

Another Spitfire Mk VB of 222 Squadron at North Weald, May 1942. This aircraft is BM202 'ZD-H' *Flying Scotsman*, one of four Spitfires built using money donated by employees of the London and North Eastern Railway, which operated the famous steam locomotive. About 1,500 Spitfires, as well as other types, were 'presentation aircraft', the result of a government money-raising scheme. Individuals, companies and organisations who contributed at least £5,000 into the Spitfire Fund could put their name or title on the fuselage, as seen here just in front of the cockpit.

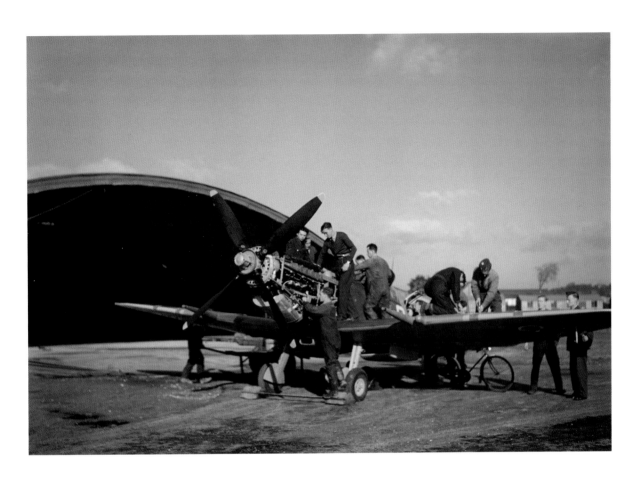

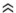

A Spitfire Mk IX of 64 Squadron undergoing maintenance at Fairlop in Essex, autumn 1942. On display is the aircraft's Rolls-Royce Merlin 61 engine, with two-stage supercharger and four-bladed propeller. This vital development gave the Spitfire a much needed boost in performance, enabling it to keep pace with the Luftwaffe's Fw 190. The Mk IX, which entered service in June 1942, was only ever intended as a stop-gap prior to the introduction of the optimised Mk VIII, but ended up as the most numerous version of the famous fighter, eventually equipping 90 RAF squadrons and serving until the end of the war.

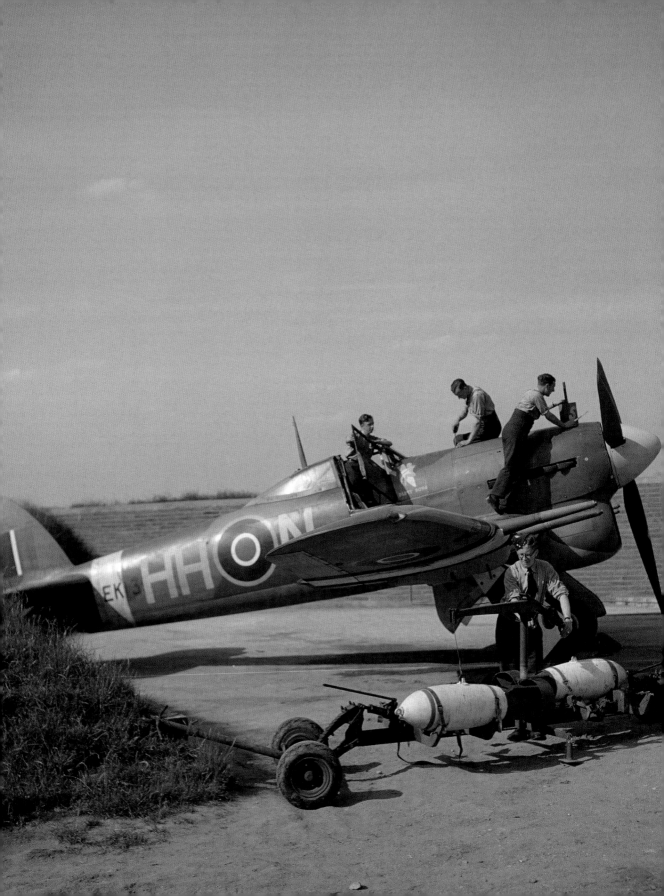

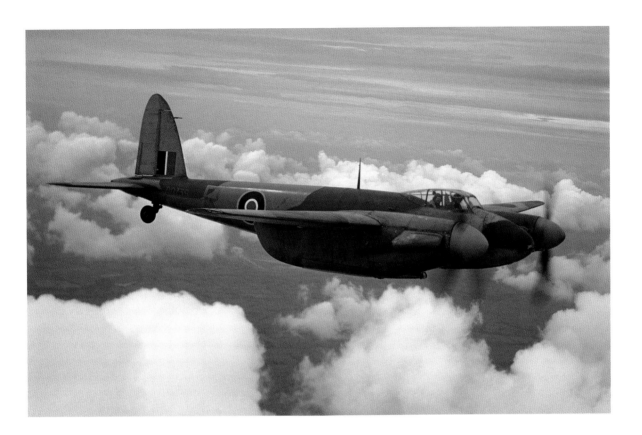

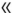

Ground staff working on Hawker Typhoon Mk IB EK139 'HH-N'
***Dirty Dora* of 175 Squadron at Colerne in Wiltshire, spring 1943.**
The Typhoon, introduced in 1941 as the successor to the
Hurricane, proved disappointing as a high altitude interceptor,
but its speed at low level meant it could catch the Fw 190 fighter-
bombers raiding targets in southern Britain. The aircraft was later
switched to the tactical support role that would make it famous.
Armed with bombs or rockets, the 'Tiffy' became the RAF's
foremost ground attack aircraft, and a key factor in the success
of Allied ground forces after D-Day.

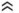

De Havilland Mosquito NF Mk II DD739 'RX-X' of 456
Squadron, Royal Australian Air Force (RAAF), June 1943.
By this date, Fighter Command Mosquitoes were flying a variety
of bomber support missions over Europe in an effort to disrupt
Luftwaffe night-fighter activities. These included '*Mahmoud*'
sorties, during which radar-equipped Mosquitoes attempted to
lure enemy fighters into mistaking them for heavy bombers and
attacking. This aircraft was shot down on one such operation,
when RAF Bomber Command raided Leipzig on the night of
3–4 December 1943. Pilot Officer John 'Tommy' May and Flying
Officer Leslie Parnell were both killed. The original censor marks
obscuring the wing-tip antennae of the Airborne Interception (AI)
Mk IV radar have been removed in this image.

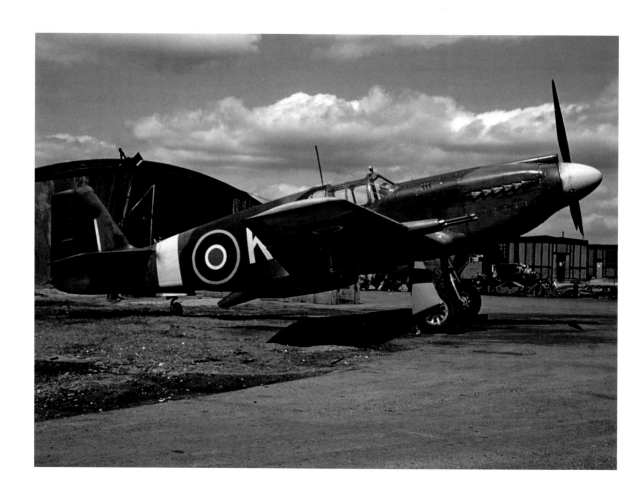

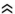

North American Mustang Mk IA FD474 'K' of 268 Squadron, 1944. The US-built Mustang was originally ordered for the RAF in 1940. Its Allison engine was unfit for high altitude combat, but excellent low-level performance and long range meant the aircraft was ideal for the tactical reconnaissance and ground attack role within Army Co-operation Command (and later 2nd Tactical Air Force). An oblique F.24 camera was fitted on the port side of the cockpit behind the pilot. The Mustang Mk I entered RAF service in January 1942, eventually equipping 23 squadrons, 6 of which also flew the Mk IA, which was an improved version armed with four 20mm Hispano cannon. The more famous Merlin-engined P-51 Mustang was also used by Fighter Command in the last year of the war.

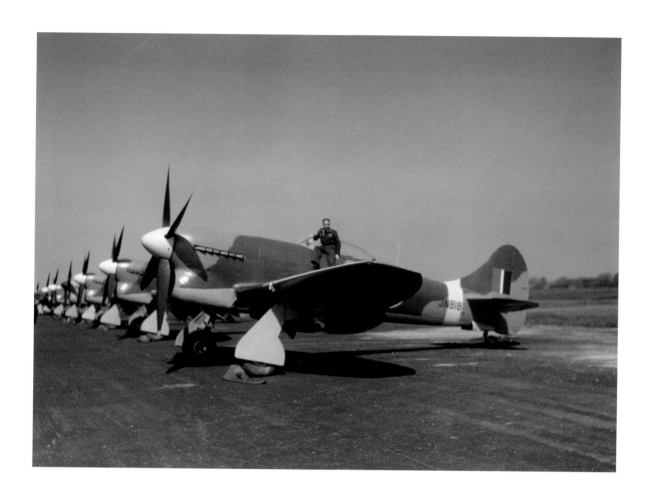

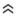

Newly built Hawker Tempest Mk Vs lined up at the company's factory at Langley, then in Buckinghamshire, June 1944. The Tempest was a development of the Typhoon and the fastest Allied fighter below 10,000ft. Its speed meant that it played a major role in anti-`Diver' operations against German V-1 flying bombs, which could reach 400mph. Tempest squadrons later joined 2 TAF for operations over Europe. The aircraft in the foreground, JN818, was flown by Squadron Leader Kenneth Wigglesworth, CO of 3 Squadron. He was killed in it on 13 September 1944 while strafing a V-2 launching site near The Hague.

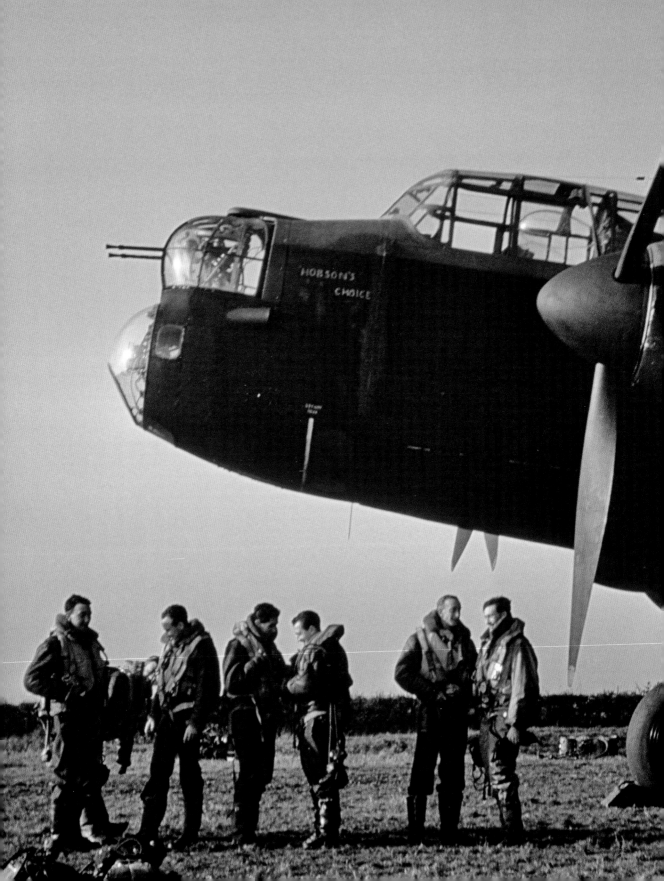

CHAPTER TWO

BOMBER COMMAND

In 1939, RAF Bomber Command was small in size, poorly equipped and constrained by a political decision to avoid endangering the lives of German civilians. Its first raids were therefore directed against enemy warships, but incurred such heavy losses that a switch to night operations was deemed necessary. Hitler's invasion of France in May 1940, and the appointment of Winston Churchill as Prime Minister, finally persuaded the British War Cabinet to sanction a long-planned strategic bombing offensive against German industry, with oil supplies the principal target. However, early operations, which saw small numbers of Wellingtons, Hampdens and Whitleys dispatched to several targets over the course of a night, were largely ineffective. Building up the force and training crews was a priority.

1941 saw the entry into operational service of the first four-engine bombers, the Stirling and Halifax. Bomb tonnage was increasing, but as the German defences strengthened so too were RAF losses. The commitment to night attacks was also causing major navigation problems. It proved almost impossible to locate and hit individual factories or oil plants, especially in marginal weather conditions. An analysis of bombing photos showed that, on average, only a quarter of crews were getting their bombs within five miles of their target. This lack of precision meant that whole cities – together with their industries and working populations – would now become the targets, and the policy of 'area bombing' was born.

There was no keener advocate of area bombing than Air Chief Marshal Sir Arthur Harris, who led Bomber Command from February 1942 until the end of the war. Harris believed that with sufficient numbers of bombers he could bring Germany to its knees. The new Lancaster gave him the tool for the job, but the size of his force increased only slowly as squadrons and crews were siphoned off to the Middle East and Coastal Command. Despite this, his 'Thousand Bomber' raid on Cologne in May 1942 was a major coup, and the

introduction of a specialist Pathfinder Force and new radio navigation devices promised significant improvements in accuracy.

In early 1943, Bomber Command was strong enough to embark on a four-month assault on the key industrial cities of the Ruhr, including Essen with its vast Krupp armaments works. Mosquitoes equipped with the new blind-bombing system 'Oboe' facilitated accurate attacks through smog and cloud. Damage was extensive, but 900 bombers were lost. In the summer, during Operation 'Gomorrah', Hamburg was consumed in a huge firestorm that left the Nazi hierarchy shaken. However, despite such destructive attacks, the morale of German citizens held out, just as that of Londoners during the Blitz had done.

Berlin was next. In the winter of 1943–1944, Bomber Command dashed itself against the German capital in a campaign that Harris claimed would decide the war. But the 'Big City' was too large, too far away and too well defended. Bombing accuracy was often poor, especially when the weather intervened. Results were similarly disappointing against other long-range targets, such as Leipzig, Stuttgart and Augsburg. In January 1944 alone, Bomber Command lost 353 aircraft and 2,000 aircrew – its worst month of the war. The Luftwaffe night-fighters were now in the ascendancy. A single raid on Nuremberg saw over 100 bombers shot down. It was a low point in the bomber offensive. In 32 major area raids, including 16 on Berlin, the RAF lost over 1,100 aircraft – more than its entire equivalent front-line strength.

In the spring of 1944, Bomber Command was placed under the control of the Supreme Commander of the Allied Expeditionary Forces, General Dwight Eisenhower, for the invasion of Europe. Support for D-Day and the Normandy campaign gave some measure of respite to the force. Attempts to isolate the battlefield by carrying out attacks on the French railway system were a great success, but the civilian population suffered tragic losses. V-weapon sites and troop concentrations were also hit, and with Allied air superiority now established some raids could be flown in daylight again. A number of effective attacks were carried out in the summer on German synthetic oil plants, now identified by the Allied High Command as the real weak spot in the enemy war machine.

For the rest of the year, a substantial part of Bomber Command's effort was directed against Germany's oil supplies and transport infrastructure, but Harris still favoured area attacks on industrial cities. The size and destructive

power of his force was expanding exponentially, and more advanced target-finding and marking techniques were coming into play. Only 226 Lancasters were required to virtually wipe out Darmstadt in September. In October, over 1,000 aircraft deluged Duisburg with 9,000 tons of bombs in a 48 hour period. With Allied armies advancing and Germany's night-fighter defences undermined, RAF losses fell drastically.

In the last four months of the war, Bomber Command, now reaching its peak strength of 1,625 heavy bombers, pulverised what was left of Germany's industrial cities. With many primary objectives destroyed, the bombers fell upon locations which had so far escaped relatively unscathed. In February, Dresden was picked out as part of an Allied plan to facilitate the advance of Soviet forces. Up to 25,000 people were killed in the ensuing firestorm. Another 17,000 died in Pforzheim 10 days later. In March, Würzburg, regarded as an important transport hub, was obliterated.

Harris's continued use of area attacks so late in the war, when the outcome was no longer realistically in doubt, caused mounting disquiet among service chiefs and politicians, including Churchill. The Germans still refused to surrender, of course, and the threat of new Nazi 'super weapons' could not be discounted, but Dresden became synonymous with the worst excesses of aerial bombing. Bomber Command's invaluable contribution to Allied victory, and its own dreadful losses, have been overshadowed by the controversy ever since.

(Previous Page)
Avro Manchester Mk IA L7483 *Hobson's Choice* of 207 Squadron with its crew at Waddington in Lincolnshire, November 1941. The Manchester was equipped with two underpowered and dangerously unreliable Rolls-Royce Vulture engines, and many aircraft were lost on operations as a result. The aircraft was not long in RAF service and production was terminated after only 202 aircraft had been completed. Fortunately, Avro had been working on a version powered by four Rolls-Royce Merlins and the legendary Lancaster was born.

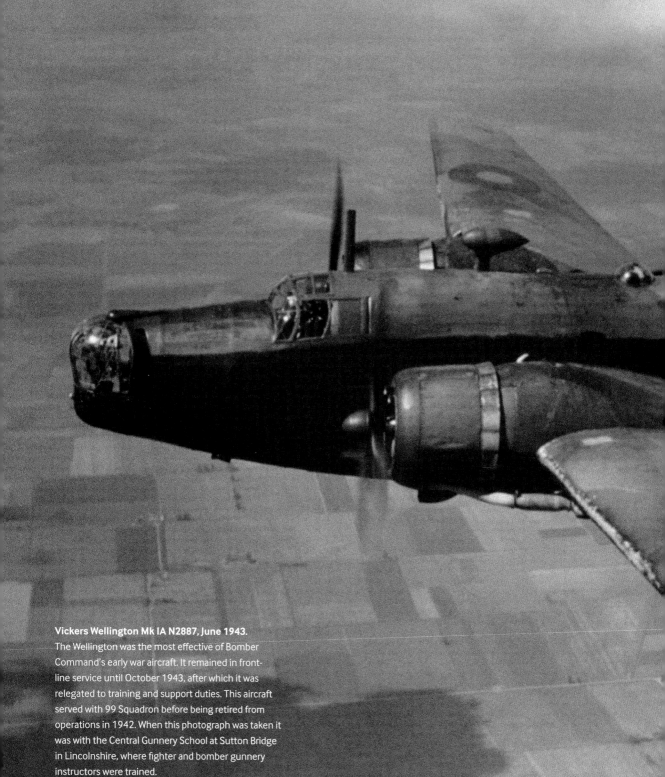

Vickers Wellington Mk IA N2887, June 1943.
The Wellington was the most effective of Bomber
Command's early war aircraft. It remained in front-
line service until October 1943, after which it was
relegated to training and support duties. This aircraft
served with 99 Squadron before being retired from
operations in 1942. When this photograph was taken it
was with the Central Gunnery School at Sutton Bridge
in Lincolnshire, where fighter and bomber gunnery
instructors were trained.

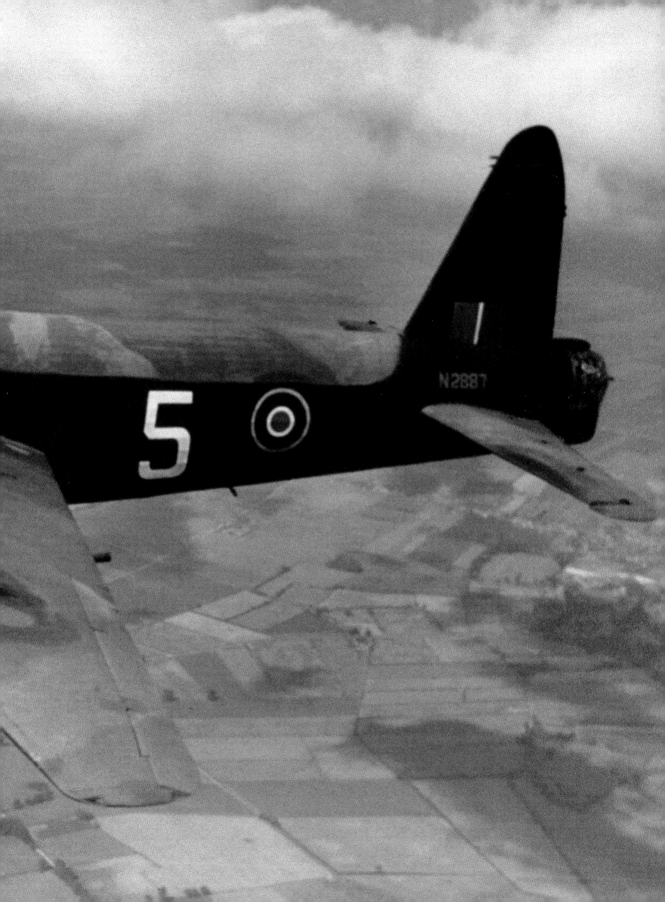

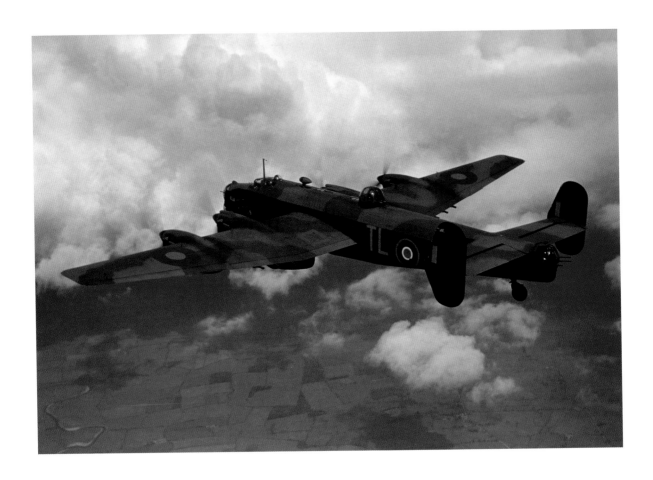

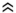

A Handley Page Halifax Mk II of 35 Squadron, June 1942. The Halifax was the second four-engine bomber to enter RAF service. Early versions suffered from serious design flaws, including tail instability and underpowered engines, which limited performance and led to heavy losses. Later variants were much improved and the aircraft served until the end of the war, but never attained the success or lasting fame of the Lancaster. This particular aircraft, W7676 'TL-P', failed to return from an operation against Nuremberg on 28–29 August 1942. It was one of 36 aircraft lost to Bomber Command that night.

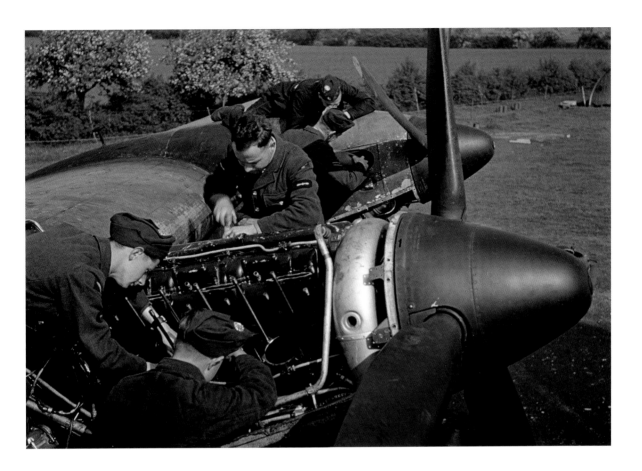

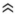

'Erks' — as junior RAF airmen were known — at work on the port Rolls-Royce Merlin XX engines of a 35 Squadron Halifax Mk II at RAF Linton-on-Ouse in Yorkshire, June 1942. Daily inspections and routine servicing were carried out in the open, exposed to the elements, as only those aircraft that survived long enough to need major overhauls or extensive repairs would normally see the inside of a hangar. A small army of ground staff, including engine fitters, airframe mechanics, instrument repairers and armourers was required to keep the aircraft flying. The Halifax Mk III, which entered service in late 1943, was powered by Bristol Hercules radial engines, which substantially increased the bomber's performance.

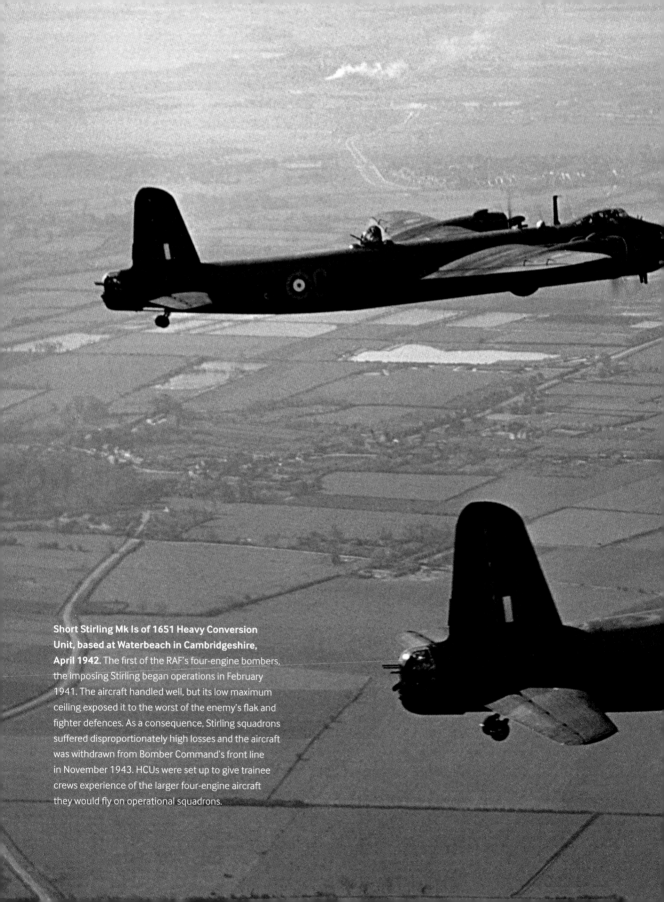

Short Stirling Mk Is of 1651 Heavy Conversion Unit, based at Waterbeach in Cambridgeshire, April 1942. The first of the RAF's four-engine bombers, the imposing Stirling began operations in February 1941. The aircraft handled well, but its low maximum ceiling exposed it to the worst of the enemy's flak and fighter defences. As a consequence, Stirling squadrons suffered disproportionately high losses and the aircraft was withdrawn from Bomber Command's front line in November 1943. HCUs were set up to give trainee crews experience of the larger four-engine aircraft they would fly on operational squadrons.

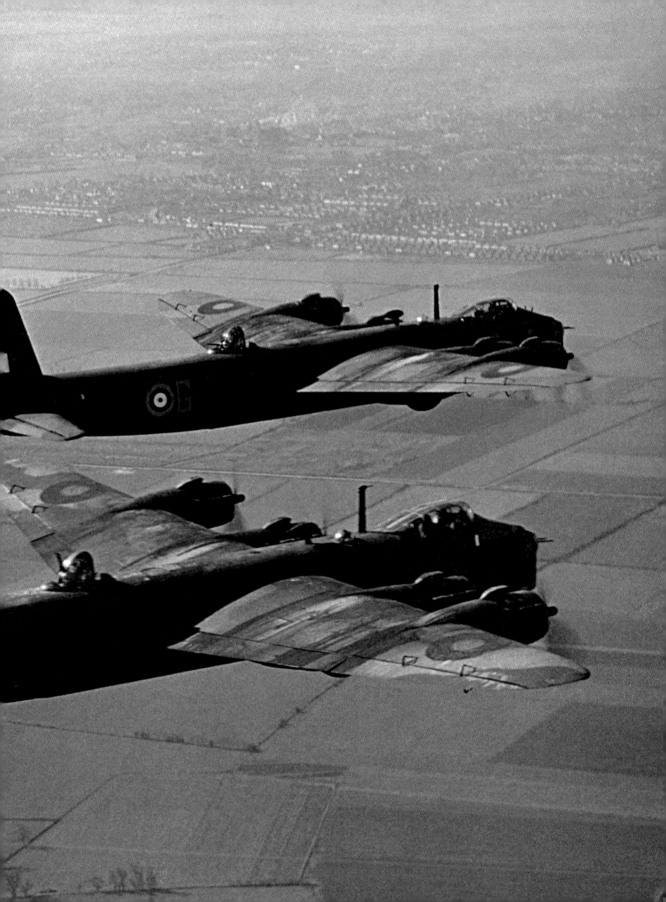

》

**An airman touches up the fuselage markings
of Lancaster Mk I R5540 at Waddington,
September 1942.** RAF squadrons were normally
identified by a two letter code – 44 Squadron, the
first to receive the Lancaster, was allocated 'KM'.
Each aircraft had a third letter as a unique call sign,
for example 'O-Orange'. A horizontal bar above could
be used to distinguish aircraft with the same identifier
when squadron strength exceeded the supply of
available letters. In this case, it was also used to denote
44 Squadron's Conversion Flight, whose function
was to initiate crews into the complexities of the
new bomber. Above this is the mid-upper turret
and its twin .303-inch Browning machine guns.

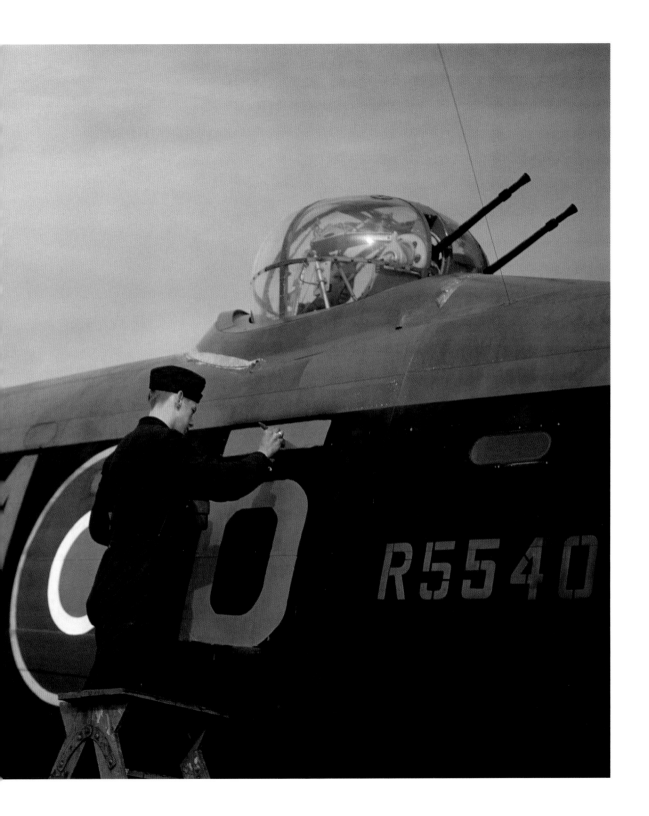

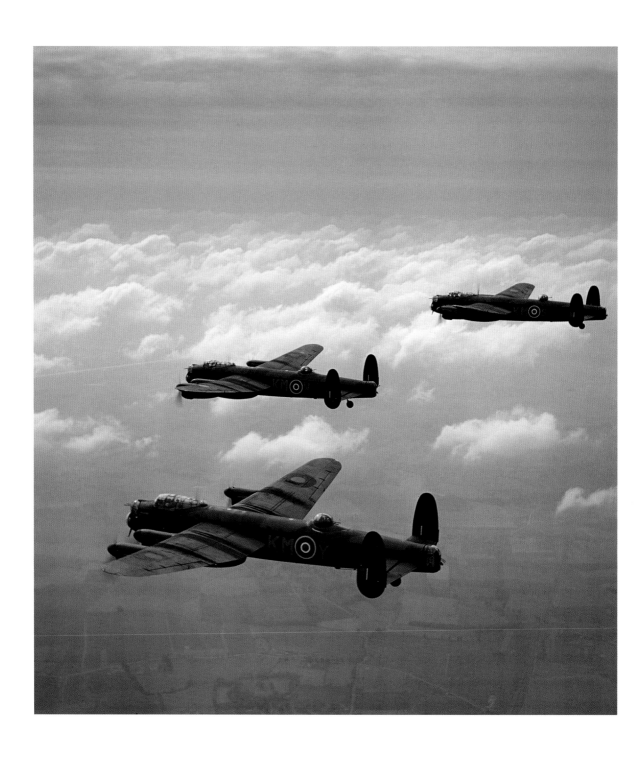

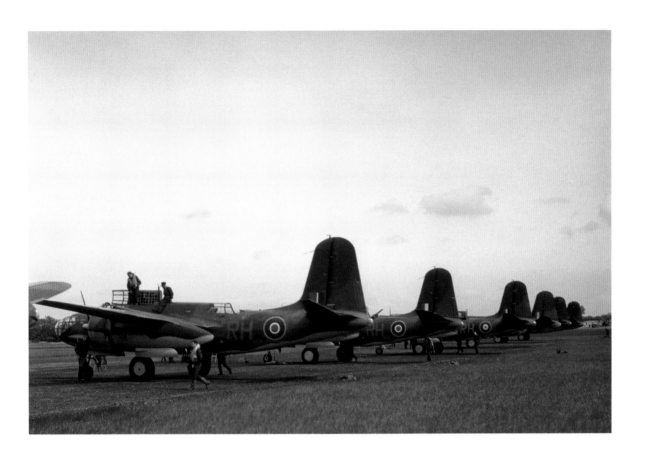

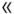

Avro Lancasters of 44 (Rhodesia) Squadron, September 1942.
Although Bomber Command switched to night bombing in late 1939, some of the first operations flown by the new Lancasters were in daylight. On 17 April 1942, a small force of 12 aircraft from 44 and 97 Squadrons carried out an audacious low-level raid against the MAN U-boat engine plant at Augsburg in southern Germany. It was hoped that Lancasters, faster and with a heavier bomb load, would succeed where other aircraft types on such missions had failed. However, seven were shot down by flak or fighters, and damage to the plant was minimal. All three of the aircraft in this photo were lost on later night operations.

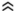

Douglas Boston Mk IIIs of 88 Squadron at Attlebridge in Norfolk, May 1942. The squadron was part of Bomber Command's 2 Group, equipped with light bombers for low-level daylight operations. The American-built Boston had been brought in to replace the Bristol Blenheim, which had proved appallingly vulnerable on such missions. It was faster and could carry a heavier bomb load. Other 2 Group squadrons converted to Lockheed Venturas and de Havilland Mosquitoes. All were transferred to 2nd Tactical Air Force in May 1943.

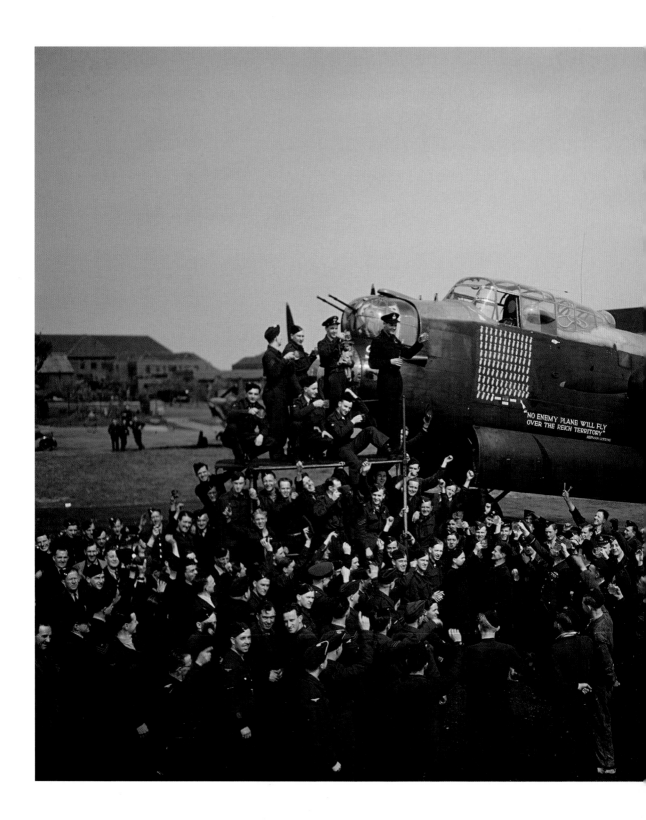

«

A total of 7,377 Lancasters were built during the Second World War, of which 3,431 were lost through enemy action. Some aircraft, however, appeared to lead charmed lives. R5868 completed 68 operations as 'Q-Queenie' with 83 Squadron, then reached the magic hundred mark as 'S-Sugar' while serving with 467 Squadron. Celebrations were held at Waddington to mark the event in May 1944, with new bomb symbols and Hermann Goering's infamous boast, 'No enemy plane will fly over Reich territory', painted below the cockpit for the occasion. The aircraft went on to complete 137 missions and now resides in the Royal Air Force Museum in London.

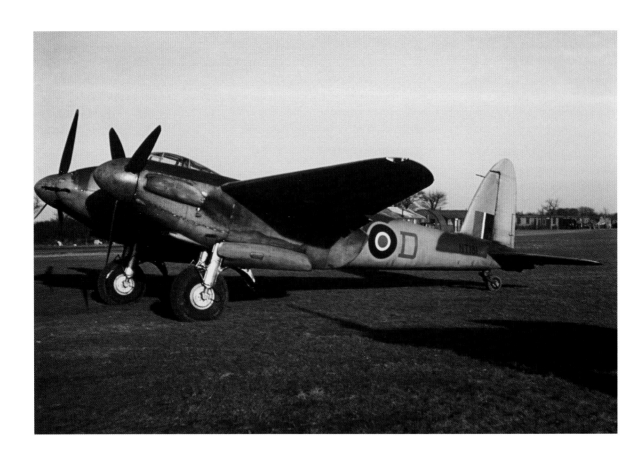

⌃

Mosquito FB Mk VI NT181 '05-D'of the Bomber Support Development Unit.
The BSDU was a trials and development unit for the RAF's 100 Group, which had
been set up in November 1943 to provide Bomber Command with electronic
countermeasures against the Luftwaffe's defences. 100 Group flew jamming,
'spoofing' (diversionary raids) and electronic intelligence gathering sorties, and
operated several bomber types. It also had seven squadrons of Mosquitoes fitted
with homing devices and radar, whose task was to hunt down enemy night-fighters.

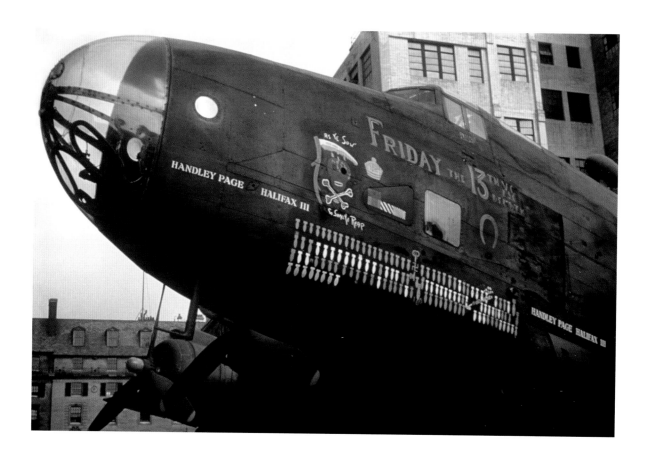

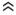

Handley Page Halifax B Mk III LV907 'NP-F' *Friday the Thirteenth* **representing Bomber Command at an exhibition of British aircraft on Oxford Street in London, June 1945.** This aircraft was another RAF bomber that cheated the odds. Delivered to 158 Squadron in March 1944, its nickname was a deliberate reference to superstition after several other aircraft coded with the 'unlucky' letter 'F' had been lost. However, LV907 completed an impressive 128 operations, the highest number of sorties by any Halifax.

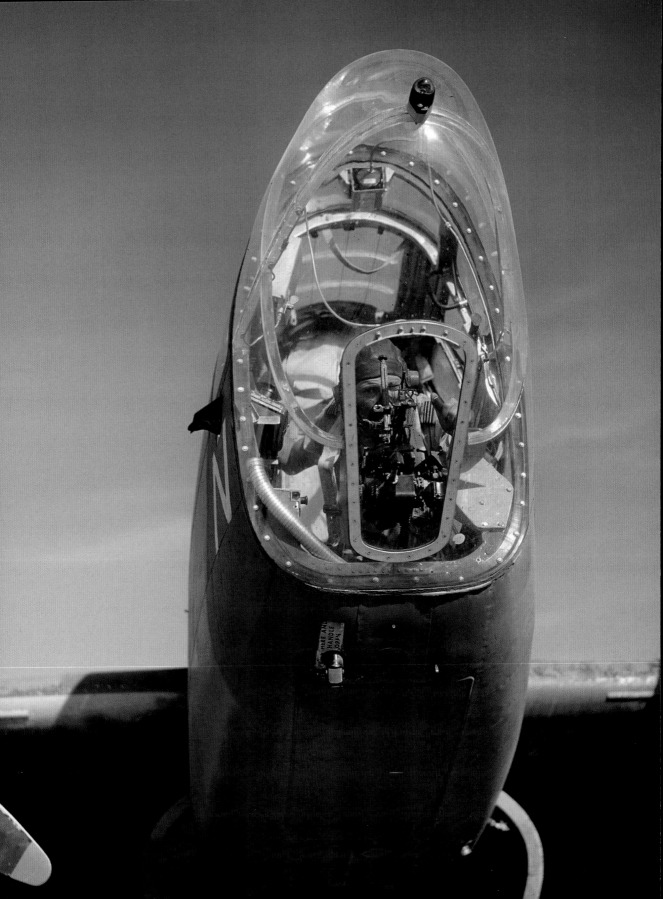

CHAPTER THREE

MEDITERRANEAN AIR WAR

In June 1940, the Italian dictator Benito Mussolini declared war on Britain. Spurred on by German successes, he hoped to gain territory in Africa and wrest control of the Mediterranean from the Royal Navy. Egypt and the Suez Canal were threatened but an Italian invasion launched in September was defeated by British forces, who then advanced deep into enemy-controlled Libya. The Royal Navy maintained its ascendancy and the RAF quickly gained the upper hand over Mussolini's numerically larger but obsolete air force.

To help his ally, Hitler despatched the *Afrika Korps,* under General Erwin Rommel, to Libya in 1941. Rommel quickly pushed the British Army back into Egypt, a rapid reversal of fortune that set the tone for the rest of the desert campaign. In the skies, RAF and Commonwealth squadrons now faced the Luftwaffe, a far tougher opponent, but gave a good account of themselves. Close air support for the army was the key focus for the RAF in the North African campaign, but aircraft engaged in these low-level missions were vulnerable to interception by enemy fighters. Luftwaffe Bf 109s, though few in number, were superior to the RAF's Hurricanes, Tomahawks and Kittyhawks at altitude, a situation only relieved with the arrival of Spitfires in 1942.

The first Spitfires in the theatre had in fact been flown off aircraft carriers to Malta, contributing to the epic defence of that strategically vital island. Despite becoming 'the most bombed place on earth', besieged Malta survived, its aircraft taking a heavy toll of Axis shipping attempting to supply Rommel's forces. RAF night raids from Egypt against key ports such as Tripoli and Benghazi also contributed to the drain on German resources.

As the campaign wore on, a shortage of fuel and other vital supplies severely limited Rommel's freedom to manoeuvre.

Allied air superiority over the front was firmly established by the time of El Alamein in October 1942, although ground fire continued to take a heavy toll. The Western Desert Air Force now comprised 30 British, Australian and South African squadrons, cooperating effectively with the army and harrying the Germans as they retreated westwards. Meanwhile, a large Anglo-American force landed in Algeria and Morocco during Operation 'Torch', supported by fresh RAF and USAAF squadrons. Despite a last minute reinforcement of Luftwaffe units, the final battles in Tunisia saw Allied aircraft firmly in control of the air.

After the defeat of Axis forces in North Africa in May 1943, the Allies turned their attention to the invasion of Sicily and the Italian mainland. Their air forces were restructured and reinforced, unlike the Luftwaffe, which was depleted by heavy losses and the transfer of units sent back to defend the Reich. From now on there would be only limited German aerial opposition. In September 1943, with Mussolini deposed and Allied bombing attacks adding to their misery, the Italians signed an armistice and joined the Allied side shortly after. However, Hitler had already ordered his troops to take over, leaving all but the very south of the country in German hands. The Allies were obliged to fight their way northwards in a bitter campaign that lasted for the rest of the war, battering through a series of German defence lines at heavy cost.

As in the desert, tactical air attacks against troop positions and transport was the primary task for the RAF and USAAF in Italy, most efficiently carried out by fighter-bombers but involving all types of aircraft as the campaign progressed. Even the heavy bombers were called in against battlefield targets, but massive destruction to such objectives as the hilltop abbey of Monte Cassino, a key position on the 'Gustav Line' south of Rome, in February 1944 achieved little other than to hinder the advance of Allied troops. More useful were attacks behind the front on railways, bridges and viaducts, targeted in a sustained campaign to disrupt the movement of German forces. Sporadic attempts by the Luftwaffe to intervene were inevitably met with an overwhelming and deadly response by Allied fighters.

Despite changing sides, Italian cities continued to suffer bombing, especially those in the north supplying Germany with armaments. Allied leaders were

keen to avoid damage to Italy's cultural heritage, but such sentiments could not impede prosecution of the war. The heavy bombers of the US Fifteenth Air Force were now also well placed to hit targets in southern and eastern Europe, beyond the effective reach of UK-based squadrons, including the vital oil refineries around Ploesti in Romania. The RAF's much smaller strategic bomber force in Italy laid mines in the Danube River, dramatically reducing barge traffic on this vital communications artery.

While the focus was always on the invasion of southern Europe, Allied air forces continued to play a key role elsewhere in the Mediterranean, with convoy protection and anti-shipping missions the main task. Operations were also flown to support British forces occupying Greece, raids were made on German island garrisons in the Aegean, and a large contingent – the Balkan Air Force – was based on the Adriatic coast of Italy for missions in support of the partisans in Yugoslavia.

(Previous Page)
The navigator and bomb aimer at his position in the nose of a Martin Baltimore Mk III of 223 Squadron in Tunisia, April 1943.
American-built Baltimore light bombers equipped several RAF and South African squadrons in the Mediterranean theatre at this time. Although generally pleased with its performance, the four-man crews were less happy with its narrow, cramped interior. Baltimores later saw action over Italy on daylight formation-bombing missions and also night interdiction sorties, the latter becoming more frequent as German forces avoided movement in daylight.

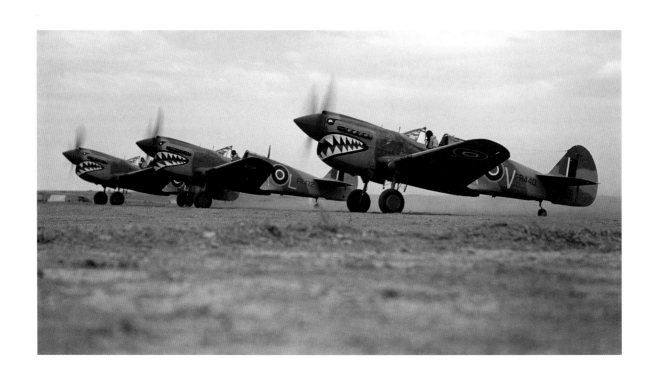

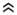

Kittyhawk Mk IIIs of 112 Squadron preparing to take off at a desert airstrip in Tunisia, April 1943. The rugged Kittyhawk was a variant of the American Curtiss P-40, a fighter supplied in large numbers and various marks to the RAF and Commonwealth air forces. It first saw action on New Year's Day 1942 and, like the earlier Tomahawk, became indelibly associated with the Desert Air Force. Although increasingly outclassed in the air superiority role as the war wore on, the Kittyhawk was able to serve usefully as a ground attack aircraft until being replaced in most squadrons by Mustangs in 1944.

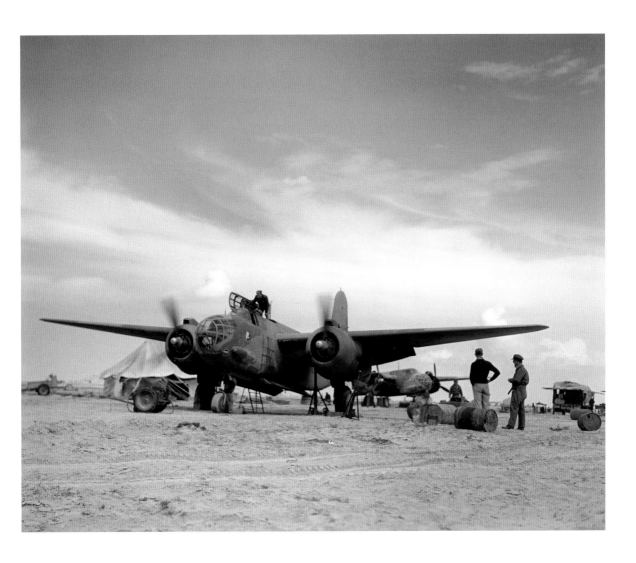

Douglas Boston Mk IIIs of 24 Squadron, South African Air Force (SAAF) in Tunisia, April 1943. The SAAF formed an important component of the Desert Air Force, with 10 squadrons of fighters, light bombers and reconnaissance aircraft involved by the time of the Battle of El Alamein. The Boston was fast, manoeuvrable and could carry a 4,000lb bomb load, but, like other light bombers, needed fighter escorts to operate effectively. Four Boston squadrons took part in the Tunisian campaign – two South African and two British. After supporting the invasions of Sicily and Italy, 24 Squadron re-equipped with Martin Marauders and continued to fly operations in Italy until the end of the war.

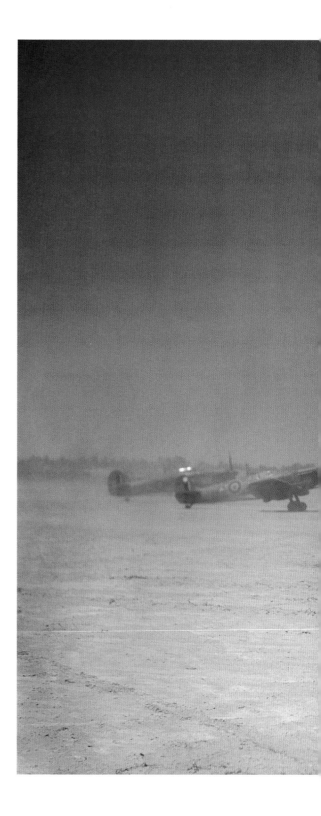

»

**'Flying tin openers': Hurricane Mk IIDs of
6 Squadron prepare for take-off from Gabes in
Tunisia, April 1943.** The squadron specialised in
anti-tank missions, and each of its aircraft was armed
with two 40mm Vickers 'S' guns designed to penetrate
enemy armour. The weapon proved highly effective,
although the Hurricanes were very vulnerable to
ground fire. On 7 April 1943, the squadron lost six
aircraft and three pilots. It later re-equipped with
rocket-armed Hurricane Mk IVs for ground attack
operations in Italy and over the Balkans in support
of Yugoslav partisans.

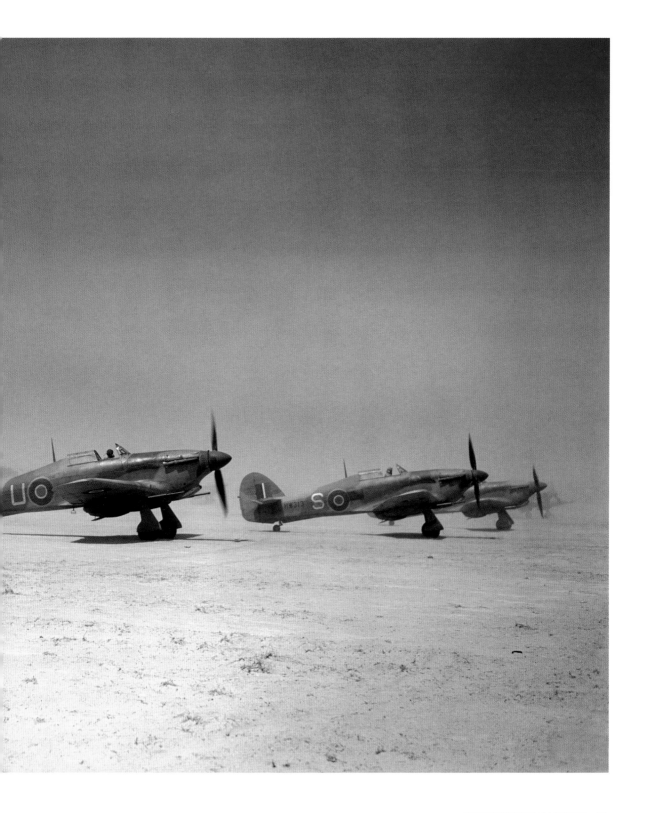

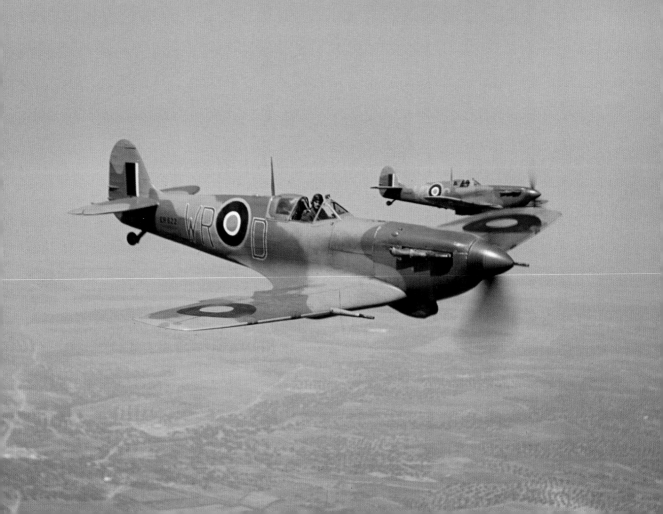

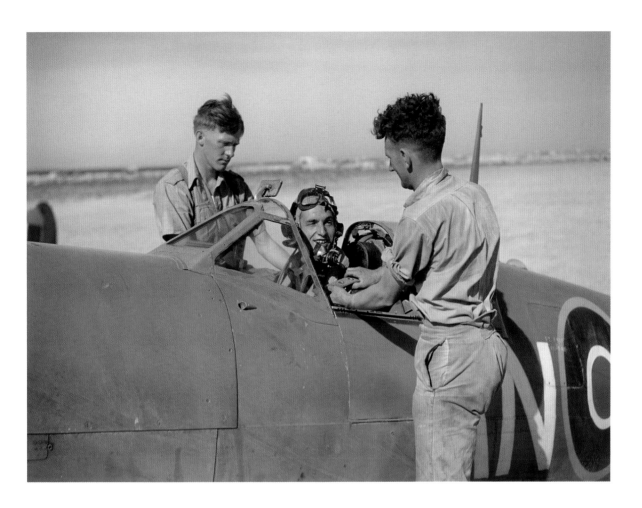

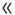

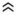

Spitfire Mk VB ER622 of 40 Squadron, SAAF in Tunisia, 1943.
Spitfires first saw action in North Africa in June 1942, having
been brought in to counter the Luftwaffe's Messerschmitt Bf
109F, which was superior to other Allied fighters. Ten additional
squadrons were transferred from RAF Fighter Command in the UK
for the Tunisian campaign, together with two Spitfire-equipped
USAAF fighter groups. Their usual task was to provide 'top cover'
for other Allied aircraft. 40 Squadron flew tactical reconnaissance
missions, its 'clipped-wing' Spitfires were optimised for low-level
operations in support of the ground forces.

**Flight Lieutenant William 'Big Bill' Pentland, a flight
commander with 417 Squadron, RCAF, being strapped in
to his Spitfire Mk VB at Goubrine in Tunisia, April 1943.** 417
Squadron was the only Canadian Air Force unit to take part in
the North African campaign, and later served in Sicily and Italy.
Pentland went on to command 440 Squadron in north-west
Europe, but was killed on 7 October 1944 when his Typhoon took
a direct hit during a dive-bombing attack on railway targets near
Wesel in Germany.

»

**Bristol Beaufighter MK VICs of 272 Squadron
on patrol off the coast of Malta, June 1943.**
The strategically vital island of Malta had been a thorn
in the side of Axis forces in North Africa, despite
suffering intense bombing attacks. It now served
as an important base from which Allied squadrons
could support the forthcoming invasion of Sicily.
272 Squadron spent most of the war in the
Mediterranean flying convoy escorts, long-range
fighter and ground attack missions.

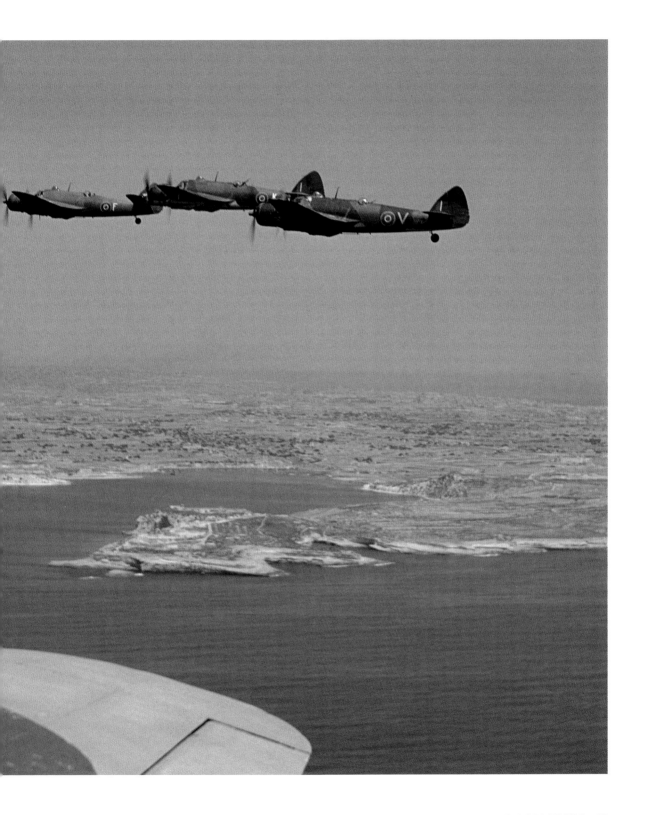

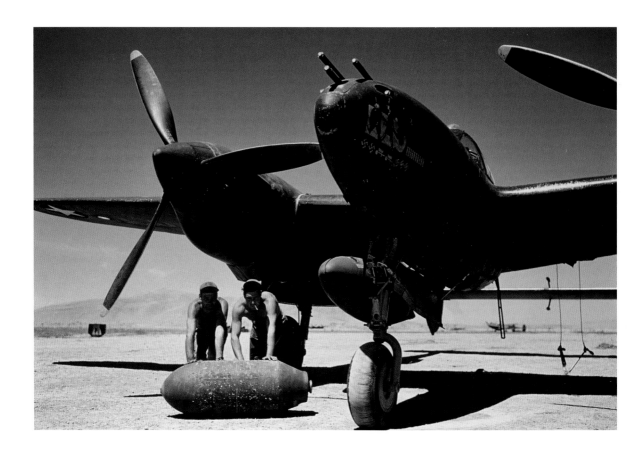

⋀

Lockheed P-38G Lightning 42-12874 'HV-4' *Beantown Boys* **of the 27th Fighter
Squadron, 1st Fighter Group at Chateaudun-du-Rhumel airfield in Algeria,
June 1943.** The 1st FG was one of three Lightning groups sent to North Africa to
cover Allied forces during Operation 'Torch' and the subsequent Tunisian campaign.
They were employed on bomber escort missions and ground attack sorties, suffering
heavy losses at first, and contributed to the great slaughter of German transport
aircraft operating from Sicily. The P-38's nose-mounted armament of four 0.50 inch
machine guns and one 20mm cannon gave it a hefty punch. 1,000lb bombs, such
as the one being manhandled here, could also be carried.

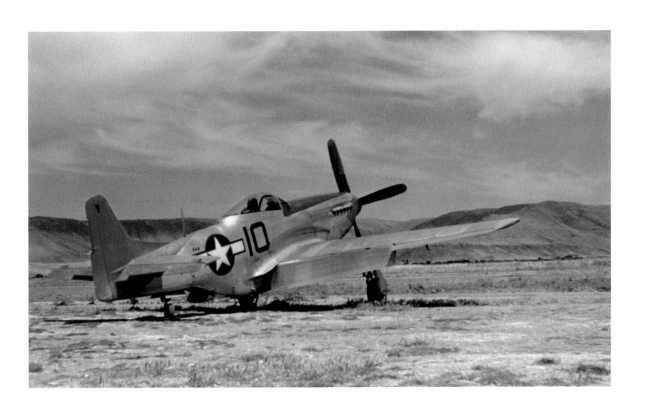

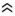

P-51D Mustang 44-15648 of the 100th Fighter Squadron, 332nd Fighter Group at Ramitelli in Italy, 1944. The 'Red Tails' were one of four Mustang groups in the Fifteenth Air Force and were famous for being the only African-American unit in the USAAF. Known as the 'Tuskegee Airmen' after their training base in Alabama, they had to endure disapproval from many in official circles opposed to black pilots. However, the 'Red Tails' lost fewer bombers in their charge than any other Fifteenth AF fighter group and destroyed 111 enemy aircraft in combat. This aircraft was flown by First Lieutenant Spurgeon Ellington, who named it *Lollipoop II*, before being passed on to First Lieutenant Robert Williams, who christened it *Duchess Arlene*.

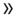

RAF fitters Wally Passmore and Jim Birkett working on the Merlin engine of Spitfire Mk VIII JF756 of No 241 Squadron at an airstrip near Termoli on the Adriatic coast of Italy, January 1944. That month, the Allies launched an amphibious assault at Anzio in an attempt to outflank the German 'Gustav Line' and capture Rome. As ever, air support was a key part of the plan, with many Allied squadrons involved in attacks intended to disrupt the movement of German reinforcements. 241 Squadron specialised in tactical reconnaissance, but also flew ground attack and escort missions.

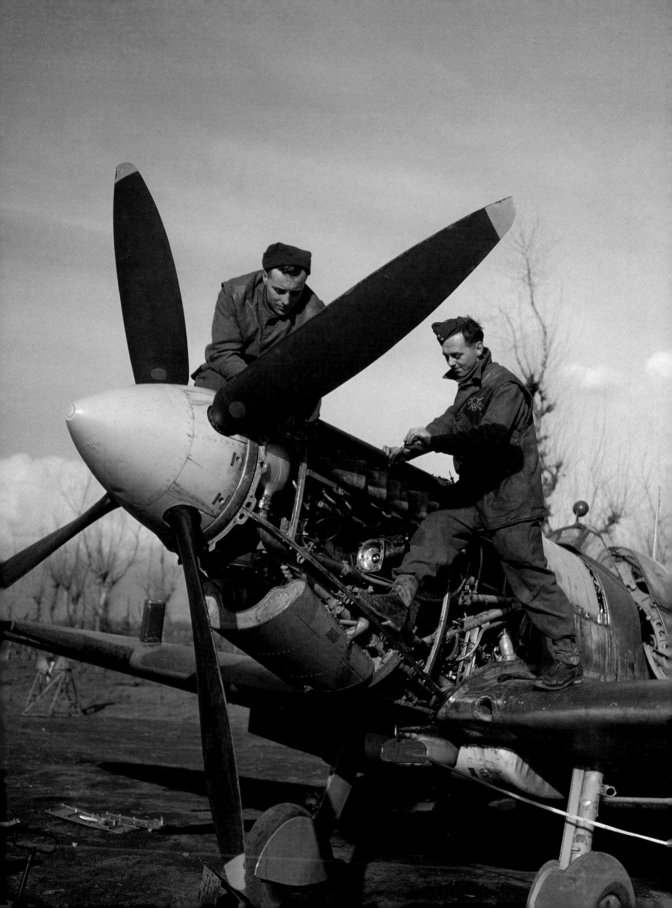

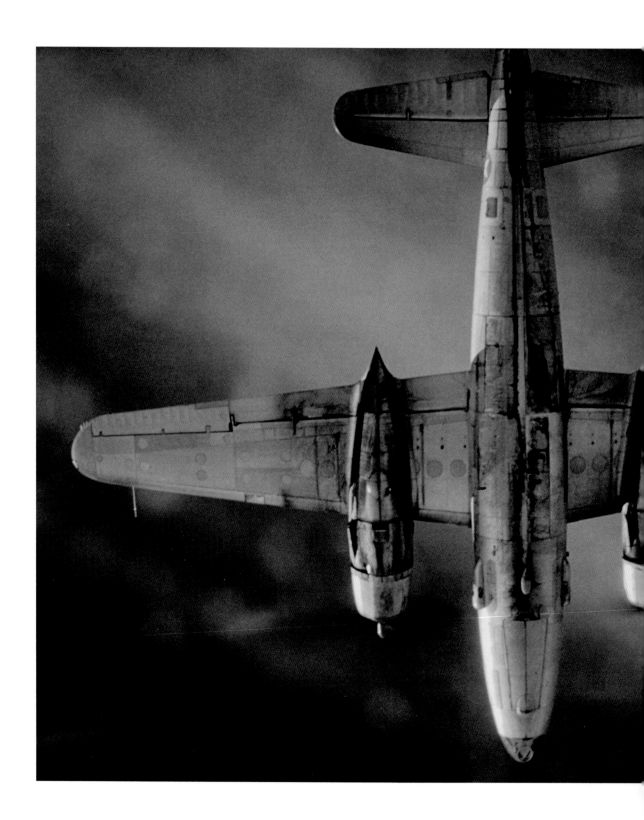

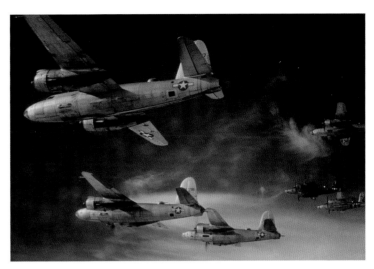

Martin B-26 Marauders of the 441st Squadron, 320th Bombardment Group, 1945. The 320th BG began operations with the Twelfth Air Force in North Africa in April 1943, with its first raids targeting shipping and ports. It then saw intensive action over Sicily and Italy, operating from Sardinia and Corsica. Bridges, road junctions and railways were frequently targeted in attempts to hinder the movement of enemy forces. The group relocated to France in November 1944, flying missions over Germany in the last months of the war. In all, the 320th BG took part in 582 combat operations for the loss of 80 aircraft.

»

Wellington GR Mk XIII JA412 'S' of 221 Squadron over the Aegean, March 1945. 221 Squadron operated with RAF Coastal Command before being transferred to the Mediterranean in January 1942, where it performed a similar anti-submarine and anti-shipping role. The Mk XIII was a specialist maritime version of the Wellington bomber, and the various aerials for its ASV (Air-to-Surface Vessel) Mk II radar can be seen. By this date the squadron was based near Athens, and this aircraft was photographed on a mercy mission to drop Red Cross supplies to villages cut off after bridges had been blown up by the retreating Germans.

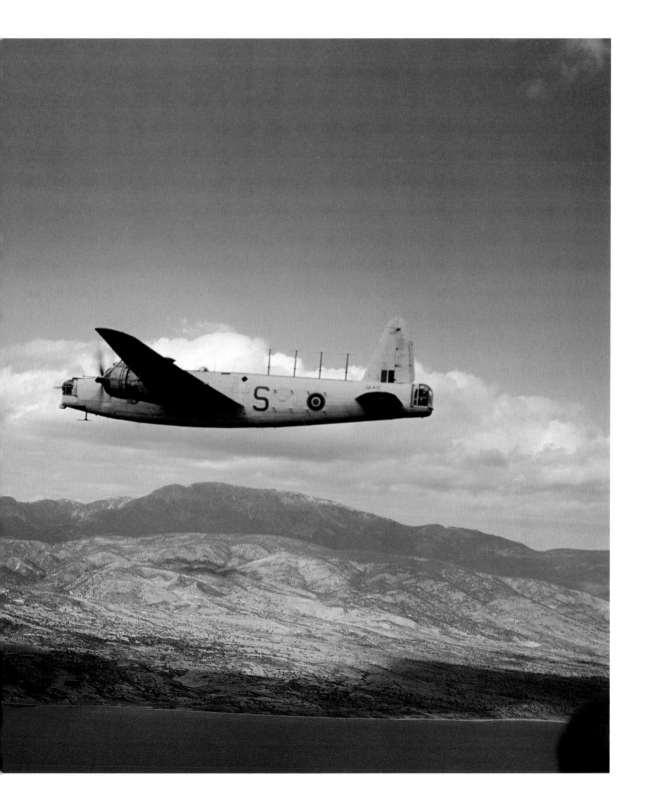

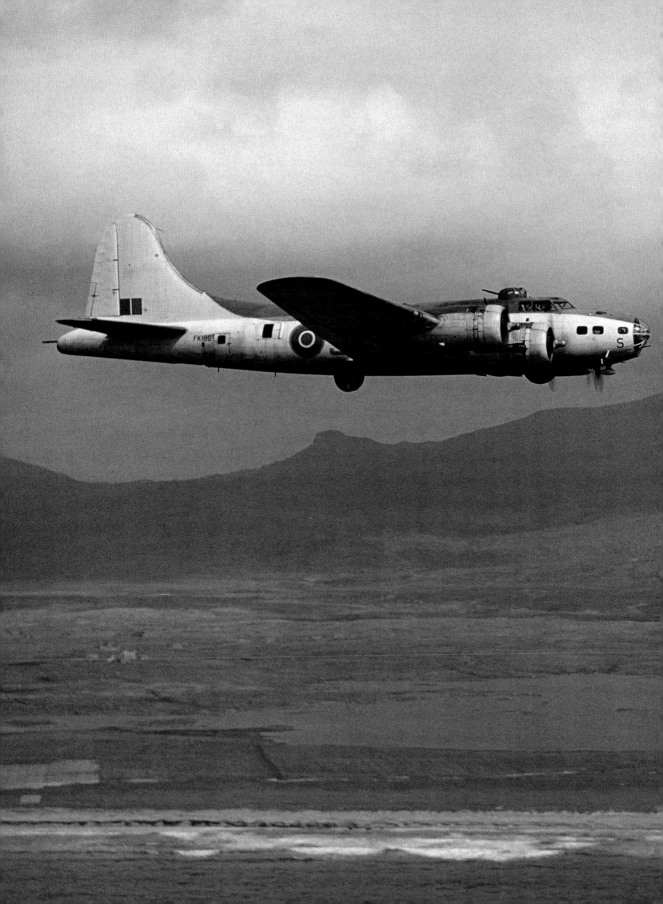

CHAPTER FOUR

MARITIME STRIKE

Allied success during the Second World War was as dependent on air superiority over the oceans as it was on controlling the skies above the battlefronts. The vulnerability of warships to air attack was revealed early on, with the Royal Navy suffering heavy losses during the evacuations from Dunkirk and Crete. Aircraft – whether land-based or operating from carriers – had clearly become the dominant threat to naval forces, no matter how well defended. Even the U-boat, which Nazi Germany chose as its principal maritime weapon, proved to be no less vulnerable to air attack.

The Royal Navy began the war with just four aircraft carriers, only one of which (HMS *Ark Royal*) was of modern design. The Fleet Air Arm, in the hands of the RAF until 1939, had been neglected, and the few hundred aircraft in service were out of date. To make matters worse, their intended replacements were either significantly delayed or failed to live up to expectations. Hurricanes and Spitfires had to be adapted for carrier operations and new purpose-built aircraft, including Wildcats, Corsairs and Avengers, ordered from the United States. These gave the Fleet Air Arm considerable fighting power. By the end of the war, 12 modern fleet carriers had been completed, together with some 44 escort carriers – the majority of the latter built in American shipyards.

Despite its early disadvantages, the Fleet Air Arm carried out many notable operations, including the strike on the Italian fleet at Taranto in November 1940, the action to track down and destroy the German battleship *Bismarck* in May 1941 and the heroic attempt to stop German capital ships during the infamous 'Channel Dash' of February 1942. In April 1944, a major attack was carried out against the *Bismarck's* sister ship, *Tirpitz*, lurking in a Norwegian fjord. Six carriers and fifteen squadrons of modern aircraft were involved, including Barracuda bombers and Hellcat fighters. It was a graphic illustration of just how much the Navy's air arm had improved in size and striking power.

The main theatre of operations for much of the war was the Mediterranean, and here Royal Navy aircraft carriers took part in vital operations to guard the fleet and protect convoys. Three were sunk in the process. They afforded air cover to Allied amphibious operations in North Africa in November 1942, the invasions of Sicily and Italy in the summer of 1943 and southern France in August 1944. The other major arena where naval aviation played an important part was the Atlantic. The advent of MAC ships (Merchant Armed Carriers), which were converted merchant vessels, and escort carriers with their complements of fighters and anti-submarine aircraft was a key development in the war against the U-boat.

The RAF had its own maritime component known as Coastal Command. In 1939, its main focus was on the North Sea and the threat from enemy surface raiders. However, from the start, U-boats were the most prolific and dangerous enemy. The German occupation of western French ports in 1940 gave them direct access to the Atlantic convoys carrying the arms, foodstuffs and raw materials on which Britain depended. Protecting this lifeline, in concert with the Royal Navy, was the principal task of Coastal Command, which was placed under Admiralty operational control in 1941.

Maritime patrol aircraft had an effect out of all proportion to their numbers. The presence of even one above a convoy was often enough to force a U-boat to abandon an attack and submerge. However, like the Fleet Air Arm, Coastal Command was initially poorly equipped. Fighter and Bomber Commands had priority for receiving newly built aircraft, with the latter particularly unwilling to relinquish its new four-engined bombers for patrol work. As the war progressed the situation gradually improved, with aircraft procured from the United States and obsolete bombers such as the Whitley and Wellington pressed into service. Technology played a major part too. New airborne radar and searchlights allowed aircraft to hunt and kill surfaced U-boats at night, and effective depth charges replaced inadequate anti-submarine bombs. However, vast tracts of the Atlantic remained beyond reach and it was here that the U-boats were most deadly.

The establishment of RAF bases in Iceland, West Africa and the Azores – and Canadian Air Force bases in Newfoundland – greatly extended air cover, but it was not until sufficient numbers of VLR (Very Long Range) Liberators were available that the so-called 'Atlantic Gap' was closed, by which time the battle was already swinging in the Allies' favour. In 1943, after several climactic convoy battles, the U-boats retreated into European waters. Coastal Command

maintained its watch and provided essential protection for the Allied invasion of Normandy in June 1944. Hitler's hopes for a resurgence using a new generation of advanced U-boats that could stay submerged for longer came to nothing thanks to the Allies' overwhelming anti-submarine forces.

Coastal Command also took up the offensive against enemy warships and merchant vessels, the latter as part of the Allies' plan to blockade Germany and interdict her supply of raw materials. The movement of Swedish iron ore from the Norwegian port of Narvik was an especially vital target. Beaufort torpedo bombers took part in early anti-shipping attacks, including strikes on capital ships, but by 1943 the Beaufighter had taken over this role. The Beaufighter squadrons, and later those equipped with Mosquitoes, were combined into dedicated strike wings, which did much to bring Germany's maritime trade to a halt.

(Previous Page)
Boeing Fortress Mk IIA FK186 'S' of 220 Squadron, based on the island of Benbecula in the Outer Hebrides, Scotland, May 1943.
With priority for British-built types given to Bomber Command, RAF Coastal Command was dependent on America for the long-range aircraft that were so vital in the war against the U-boat. The B-24 Liberator was the most important, but B-17 Flying Fortresses of various marks equipped 3 squadrons and were responsible for sinking 11 U-boats. Later in the year, 220 Squadron moved to Terceira in the Azores, another remote location but one which extended Coastal Command's reach further out into the Atlantic.

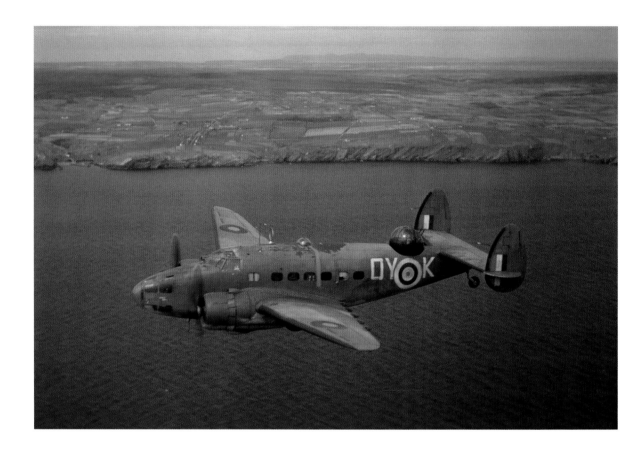

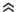

Lockheed Hudson Mk V AM853 'OY-K' of 48 Squadron, based at Wick in Scotland, early 1942. American-built Hudsons played an important role in RAF Coastal Command during the early years of the war, flying convoy patrols and anti-submarine sorties, as well as hazardous anti-shipping operations off the Norwegian coast. 48 Squadron lost 20 aircraft in the first 3 months of 1942 alone. In December of that year, the squadron was transferred to Gibraltar to help guard the gateway into the Mediterranean.

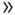

Short Sunderland Mk I L5802 'SE-F' of 95 Squadron at Pembroke Dock in South Wales, 1941. The giant Sunderland flying boat was the only RAF Coastal Command aircraft in front-line service throughout the war, but was actually a less effective submarine hunter than land-based, long-range aircraft. Nevertheless, Sunderlands were wholly or partly responsible for the destruction of 38 German and Italian U-boats. In March 1941, 95 Squadron moved to Freetown in Sierra Leone and remained in West Africa for the rest of the war, providing cover for convoys heading into the South Atlantic. This particular aircraft later served with Australian-manned 461 Squadron and 4 (Coastal) Operational Training Unit before being written off in an accident in January 1943.

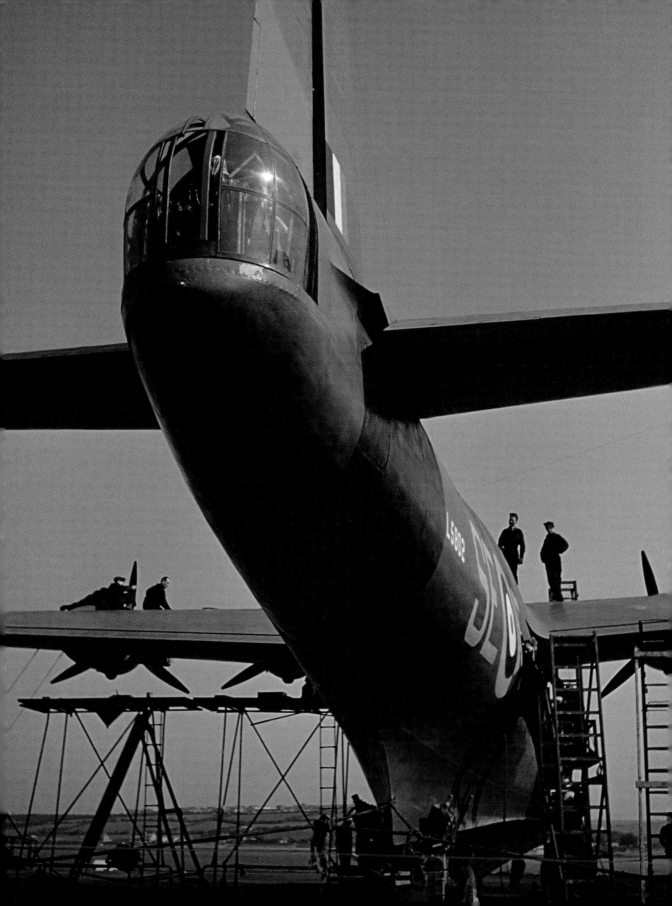

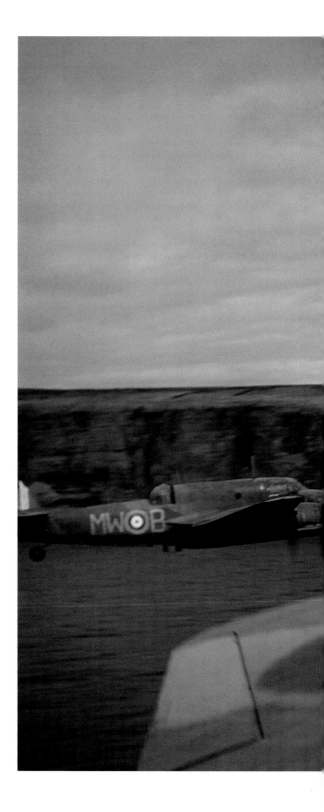

»

**Bristol Beauforts of 217 Squadron flying along
the Cornish coastline near St Eval, January 1942.**
The Beaufort was designed as a torpedo bomber but
also carried out bombing and mine-laying sorties. The
lead aircraft, N1173 'MW-E', was one of three Beauforts
shot down on 12 February 1942 during the 'Channel
Dash', when three German battlecruisers sailed from
Brest to their home ports via the English Channel.
The British response was muddled and strikes by
the RAF, FAA and naval forces all failed, although
Scharnhorst and *Gneisenau* were damaged by mines
before reaching German waters. By the summer,
Coastal Command's Beauforts had been re-deployed
overseas, their role taken over by Beaufighters.

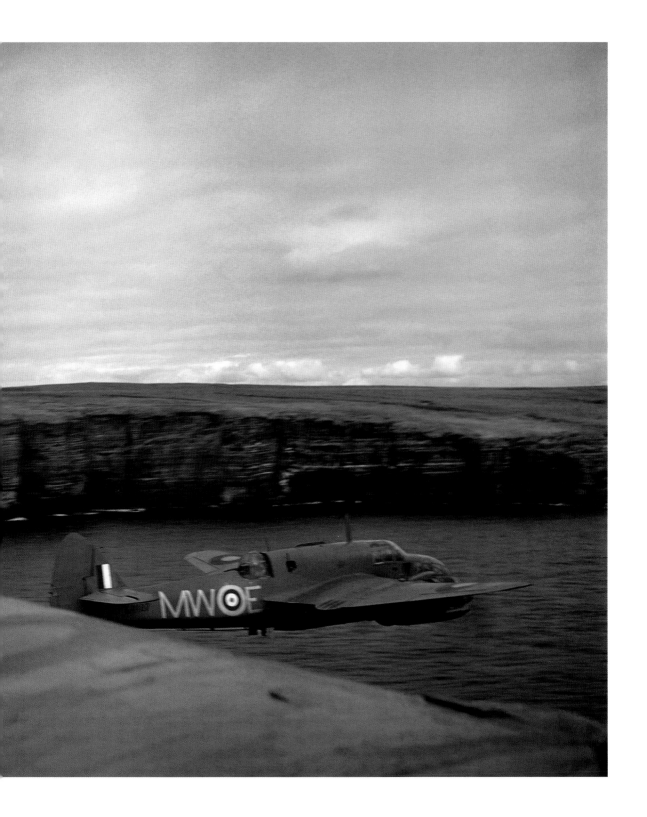

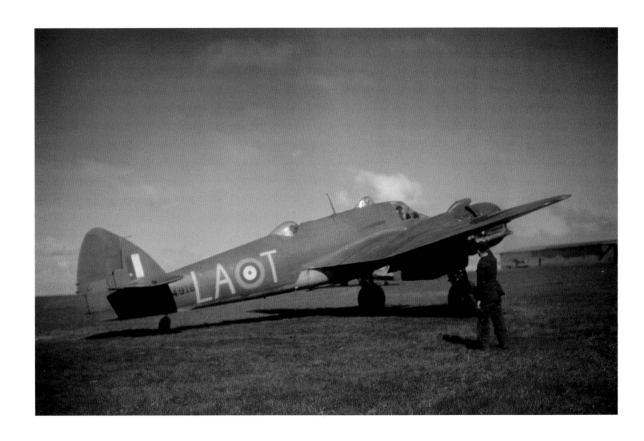

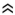

Bristol Beaufighter Mk IC T4916 'LA-T' of 235 Squadron, 1942. The Beaufighter
was introduced into RAF Coastal Command as a long-range fighter, convoy escort
and anti-shipping aircraft, replacing its obsolete Beauforts and Blenheims. Some
operated far out over the Bay of Biscay against German maritime aircraft. Beaufighter
squadrons were later grouped into strike wings, carrying out coordinated low-level
attacks on German merchant vessels and their escorts off the coast of occupied
Europe using a combination of cannon fire, torpedoes and rockets.

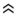

Handley Page Hampden AT137 'UB-T' of 455 Squadron, RAAF, based at Leuchars in Scotland, May 1942. The Hampden was one of the RAF's early war bombers, later adapted for torpedo attacks with RAF Coastal Command. They flew most of their missions against merchant shipping off the south-west coast of Norway. A contingent was also based for a time at Vaenga in the Soviet Union to protect PQ-18, a Murmansk-bound convoy, from enemy surface raiders. The aircraft were withdrawn from service at the end of 1943.

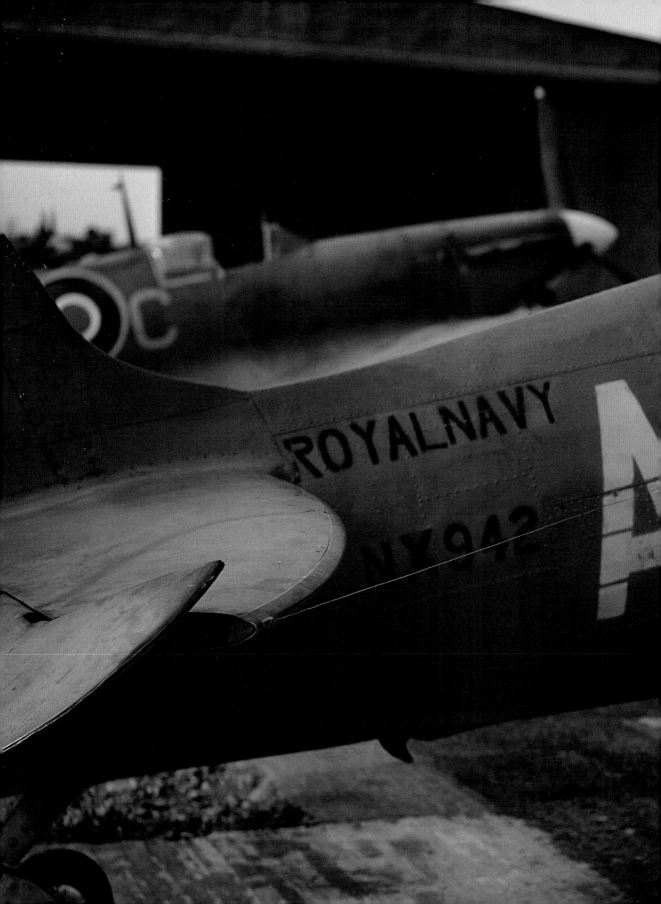

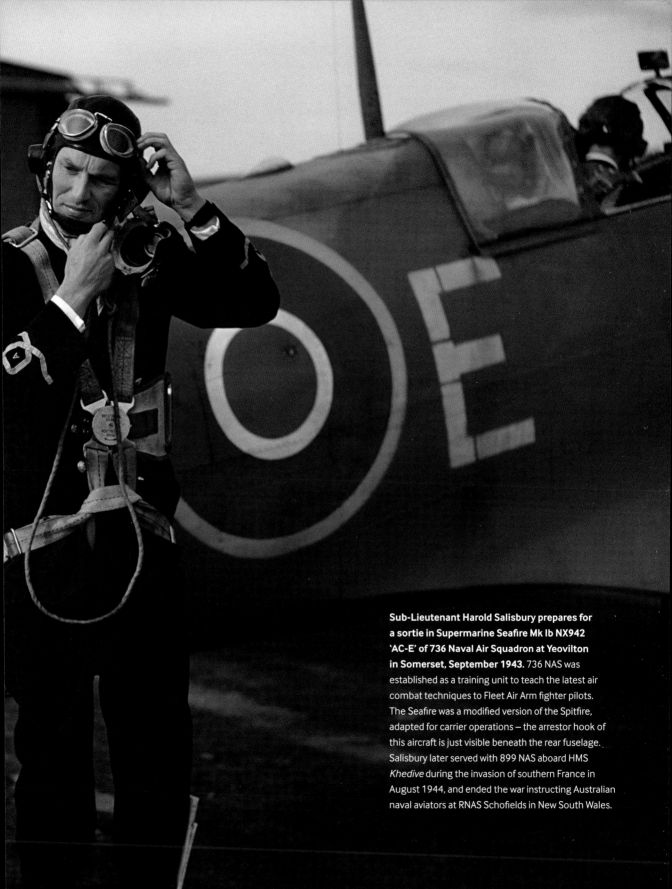

Sub-Lieutenant Harold Salisbury prepares for a sortie in Supermarine Seafire Mk Ib NX942 'AC-E' of 736 Naval Air Squadron at Yeovilton in Somerset, September 1943. 736 NAS was established as a training unit to teach the latest air combat techniques to Fleet Air Arm fighter pilots. The Seafire was a modified version of the Spitfire, adapted for carrier operations – the arrestor hook of this aircraft is just visible beneath the rear fuselage. Salisbury later served with 899 NAS aboard HMS *Khedive* during the invasion of southern France in August 1944, and ended the war instructing Australian naval aviators at RNAS Schofields in New South Wales.

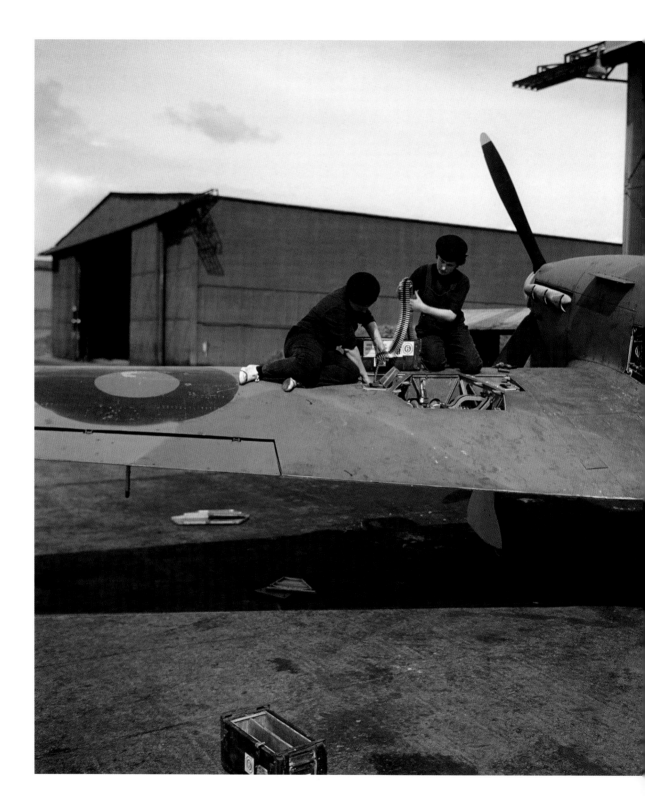

《

**'Wrens' (members of the Women's Royal Naval
Service) loading the guns of a Royal Navy Sea
Hurricane at Yeovilton, September 1943.**
Owing to a lack of high-performance carrier fighters,
the Hawker Hurricane had been pressed into naval
service. Its limited endurance and non-folding wings
were major problems, but it had some success as
a shipboard fighter during 1941–1942, pending
deliveries of the more suitable American Grumman
Wildcat. The last Sea Hurricanes were withdrawn
from service in September 1944.

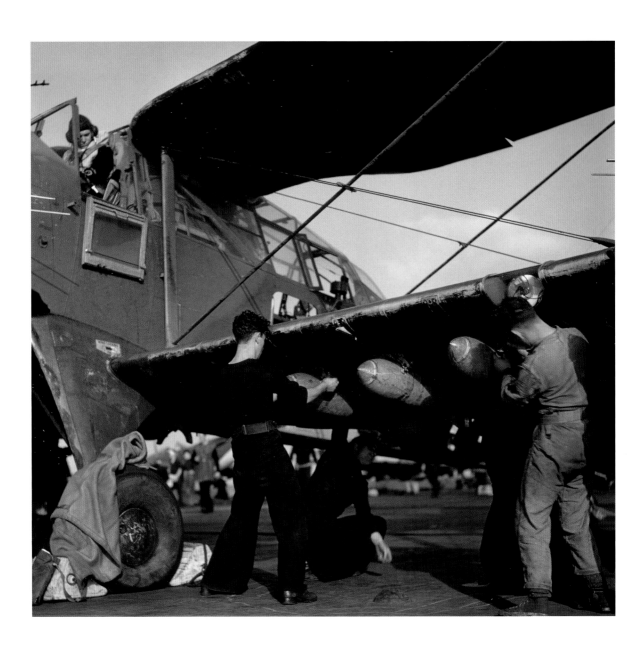

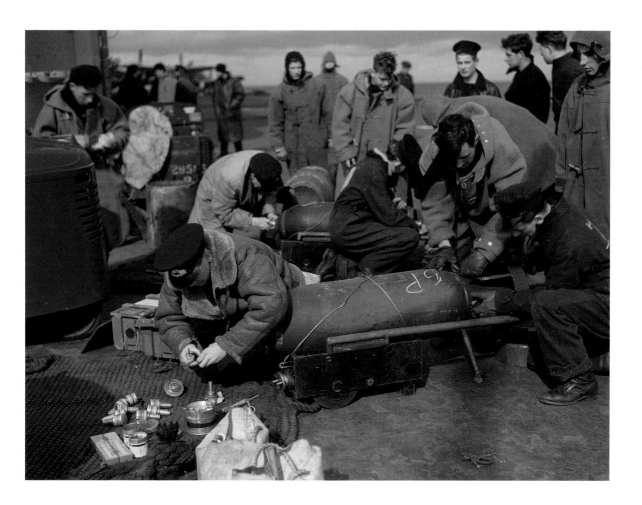

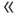

A Fairey Albacore of 820 NAS being loaded with 250lb bombs on board HMS *Formidable* during Operation 'Torch', the Anglo-American landings in north-west Africa, November 1942.
The ungainly Albacore, which equipped a total of 15 FAA squadrons, was intended to replace the Fairey Swordfish in the torpedo, bomber, reconnaissance role, but in fact offered little improvement. During 'Torch', Albacores operated from three fleet carriers, bombing Vichy French airfields and coastal defences, and providing anti-submarine cover.

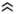

Armourers fusing bombs on board HMS *Victorious* in preparation for Operation 'Tungsten', a major Fleet Air Arm raid on the *Tirpitz* in Kaafjord, Norway, 3 April 1944.
Four squadrons of Barracudas carried out two dive-bombing attacks, with Wildcats and Hellcats strafing the ship and shore batteries. *Tirpitz* was hit by 15 bombs, which caused widespread damage and inflicted heavy casualties. Two near misses resulted in flooding in some compartments. Follow-up attacks in the summer were unsuccessful, but the ship was kept out of action until it was eventually sunk by RAF Lancasters in November 1944.

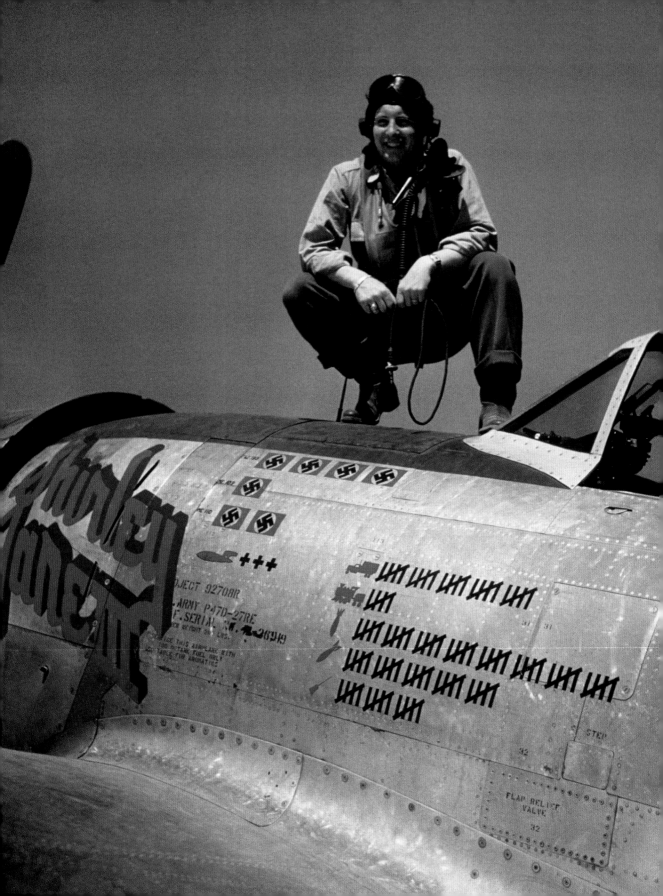

CHAPTER FIVE

USAAF OVER THE REICH

The US Eighth Air Force began strategic bombing operations from Britain on 17 August 1942, when 12 B-17s attacked marshalling yards at Rouen. The American build-up was initially slow, and early missions were small in scale and directed against targets in occupied Europe. The USAAF regarded precision attacks on key German industries as its prime mission, and although area bombing as a policy was rejected, later blind-bombing attacks through cloud using radar amounted to the same thing. Unlike RAF Bomber Command, the Eighth flew in daylight, believing its heavily armed B-17 Flying Fortresses and B-24 Liberators could fight their way through to their targets. Though the British had serious doubts, it offered the enticing prospect of 'round the clock' bombing.

At the Casablanca Conference in January 1943, Allied leaders agreed on a joint Anglo-American bombing programme that aimed to critically weaken Germany's economic and military structure prior to a planned invasion of Europe. The strategic plan was known as Operation 'Pointblank'. Key targets for the USAAF were U-boat construction sites, oil supplies, ball bearing factories and transport, but before any of that could be achieved the Luftwaffe fighter force had to be neutralised by attacks on aircraft manufacturing plants.

However, as American bombers extended their attacks into Germany during 1943 their losses began to mount. P-47 escort fighters could only accompany them part of the way, even with extra fuel tanks. Once the bombers were exposed, they were easy prey for the Luftwaffe. On 17 August 1943, 60 out of 376 B-17s were shot down attacking the Messerschmitt plant at Regensburg and ball bearing factories at Schweinfurt. A second raid on

Schweinfurt in October saw another 60 aircraft fail to return. Such losses were unsupportable and deep-penetration raids were curtailed as the winter weather closed in.

Meanwhile, the Ninth Air Force, previously operational in the Mediterranean, was reactivated in Britain. Its fighters and medium bombers concentrated on 'tactical' targets such as bridges, gun emplacements and airfields, and would provide close support for US Armies during the forthcoming invasion of Europe. The Ninth was to be a mobile force, relocating to airstrips and captured airfields on the continent after D-Day and keeping pace with the Allied advance.

For the Eighth Air Force, now expanding rapidly, long-range fighter escort was the critical factor. The twin-engine P-38 Lightning had sufficient endurance but suffered recurring engine problems at high altitude. Fortunately, at the end of 1943 the first P-51 Mustangs became available, possessing both range and outstanding performance. Their appearance coincided with the adoption of more aggressive tactics. Defending the bombers was no longer the sole aim, and from now on US fighters would actively seek out and destroy the Luftwaffe. The hunters had become the hunted.

A period of fine weather in February 1944 allowed the launch of Operation 'Argument' (also known as 'Big Week') – several days of attacks on aircraft assembly and aero-engine plants. Damage on the ground was not as crippling as was hoped, but the results of the air battle were more profound. 'Big Week' cost the Luftwaffe 355 aircraft and 150 pilots. On 6 March, the Eighth raided Berlin. Both sides suffered heavy losses, but while the Americans were now receiving ample replacement crews and aircraft, the Luftwaffe day-fighter force had begun a catastrophic decline. The US escort fighters, especially the P-51s, were winning control of the skies over the Reich.

In April, control of the US strategic bomber force was temporarily assigned to General Eisenhower's headquarters for the forthcoming invasion. The principal task now was to disrupt the French railway system. The Ninth Air Force played an important part, hitting bridges and marshalling yards. Another priority was Operation 'Crossbow', the campaign against Hitler's 'vengeance' weapons. V-1 launching sites were frequent objectives for both the heavy and medium bombers. On top of this, when the weather allowed, the Eighth continued its deep-penetration raids into Germany. In the immediate run-up to D-Day coastal defences were targeted, and with the

Allies ashore in Normandy the bombers were often called in to support the army, blanketing enemy troop concentrations.

The most important target in 1944 was synthetic fuel. Germany depended greatly on oil produced from coal to offset its limited natural supplies. In May, the Eighth began targeting this vital industry. Production was almost halved by July and continued to fall dramatically as attacks were stepped up during the autumn. German military operations were massively disrupted. Starved of aviation fuel, the Luftwaffe could now offer only sporadic resistance. For maximum effect the plants had to be hit repeatedly and losses were sometimes heavy, but the results were decisive.

In December 1944, USAAF aircraft of all types were called in against German forces and supply routes during Hitler's surprise counter-offensive in the Ardennes. On Christmas Eve, the Eighth mounted its greatest effort of the war, when 2,046 heavy bombers and 853 fighters operated against various communications targets. Transport remained a top priority into 1945. Operation 'Clarion' in February was a sustained and widespread two-day assault aimed at paralysing the German railway system. The Eighth Air Force's largest raid of the war on a single target occurred on 18 March 1945, when 1,329 aircraft bombed the Nazi capital. The lack of aerial opposition was a fitting testament to the USAAF's supreme achievement – the destruction of the Luftwaffe over Europe.

(Previous Page)
Captain Edwin 'Bill' Fisher of the 377th Fighter Squadron, 362nd Fighter Group atop his P-47D Thunderbolt *Shirley Jane III* at a landing ground in France, summer 1944. The 362nd FG was one of 13 groups of Thunderbolts assigned to the Ninth Air Force, tasked with providing tactical support for US Armies during the invasion of Europe. The P-47s flew many successful fighter sweeps and ground attack missions against road and rail transport, as the impressive scoreboard on the side of his aircraft graphically illustrates. Fisher also shot down seven enemy aircraft and destroyed three V-1 flying bombs in mid-air.

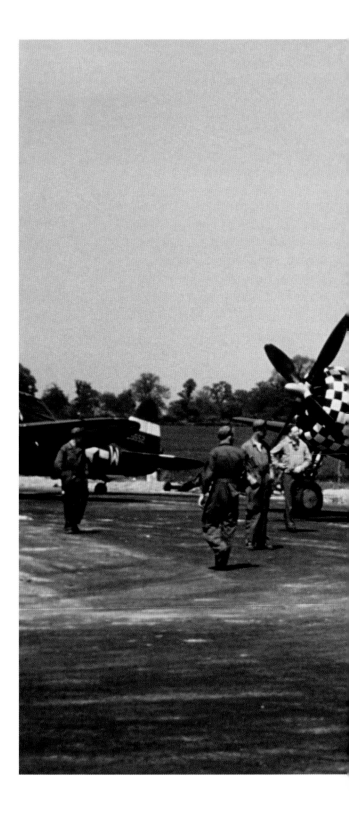

》

Republic P-47D Thunderbolts of the 83rd Fighter Squadron, 78th Fighter Group at Duxford, spring 1944. The 78th FG was based at the Cambridgeshire airfield from April 1943 until the end of the war. Its aircraft wore distinctive black and white checkerboard identification markings. The rugged and heavily armed P-47 was an effective escort fighter, but even with increased internal fuel capacity and fitted with drop-tanks, which stretched its radius of action to 475 miles, it was still unable to accompany the bombers to the furthest targets. In December 1944, the 78th exchanged its aircraft for P-51 Mustangs.

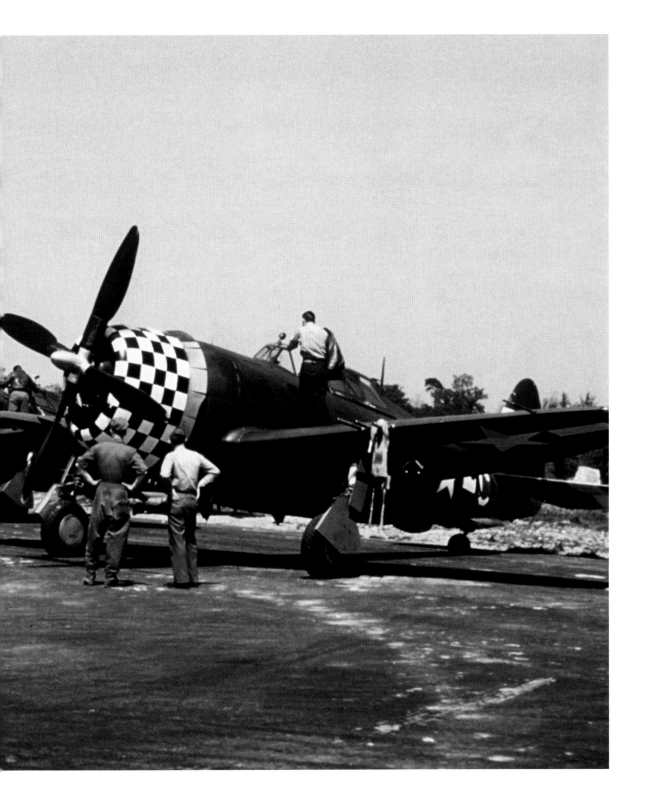

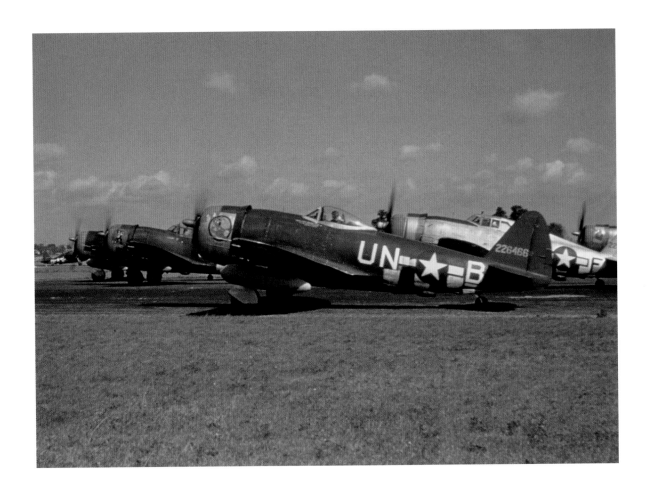

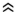

Identified by their scarlet nosebands, P-47D Thunderbolts of the 63rd Fighter Squadron, 56th Fighter Group prepare to takeoff on an escort mission from Boxted in Essex, summer 1944. The 56th FG was known as the 'Wolfpack' and had more ace pilots in its ranks, and destroyed more enemy aircraft in the air than any other Eighth Air Force fighter group. The foreground aircraft, 42-26466, is *Anamosa II*, flown by Captain Russell B Westfall. The 'bubble hood' canopy and cut down rear fuselage of this latest model of P-47 gave the pilot greater visibility to the rear compared with the earlier 'razorback' version, as seen behind.

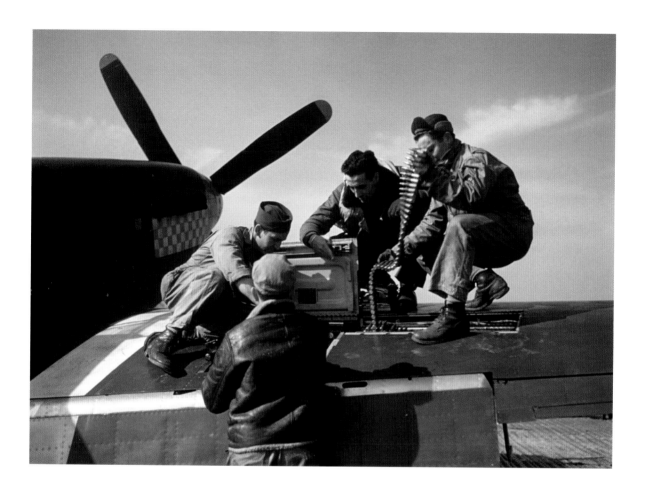

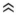

The 4th Fighter Group's leading ace, Captain Dominic 'Don' Gentile (2nd from right), watches as his ground crew load belts of .50-inch ammunition into his North American P-51B Mustang _Shangri-La_ at Debden in Essex, March 1944. The 4th FG was the first Eighth Air Force fighter group to fly missions over Germany, its nucleus being the RAF's three American-manned 'Eagle Squadrons'. Described by General Eisenhower as a 'one-man air force', Gentile was sent back to the States in April 1944 after completing his tour and becoming the Eighth's top scorer with 21 aerial victories. By the war's end, only five other US pilots in the ETO had exceeded this number.

**P-51 Mustangs of the 487th Fighter Squadron,
352nd Fighter Group at Bodney in Norfolk,
spring 1945.** Mustangs flew their first escort missions
in December 1943, with the improved P-51D model
entering service in May 1944. The Mustang was
the definitive escort fighter, possessing the range
to shepherd the US bombers on deep-penetration
missions — 850 miles, or beyond Vienna, when fitted
with 108-gallon drop tanks — and the performance
to match the best Luftwaffe fighters. The 352nd,
nicknamed the 'Blue-nosed Bastards of Bodney',
were credited with 519 confirmed air-to-air kills.

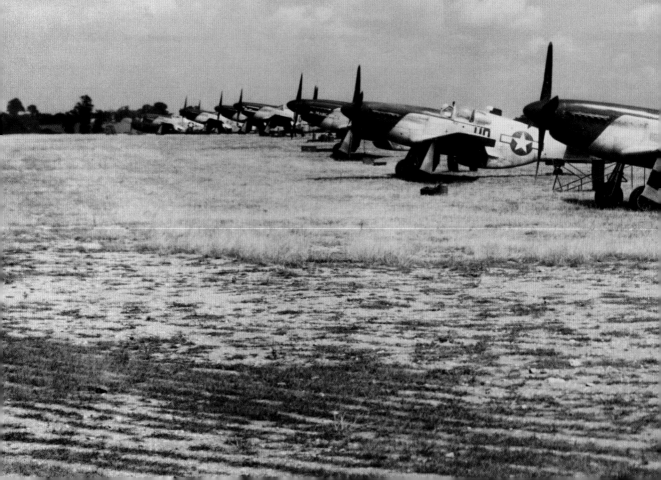

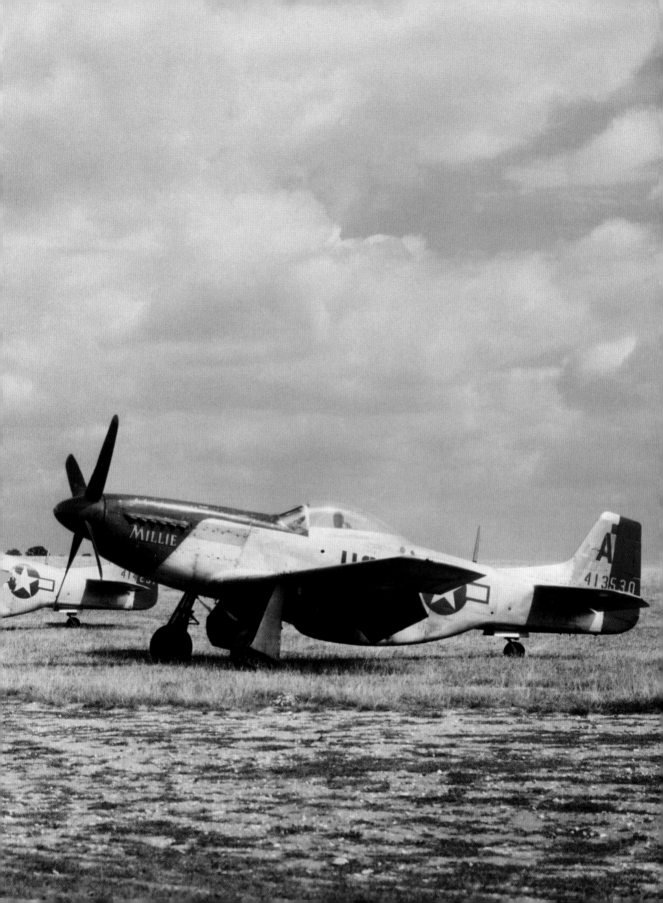

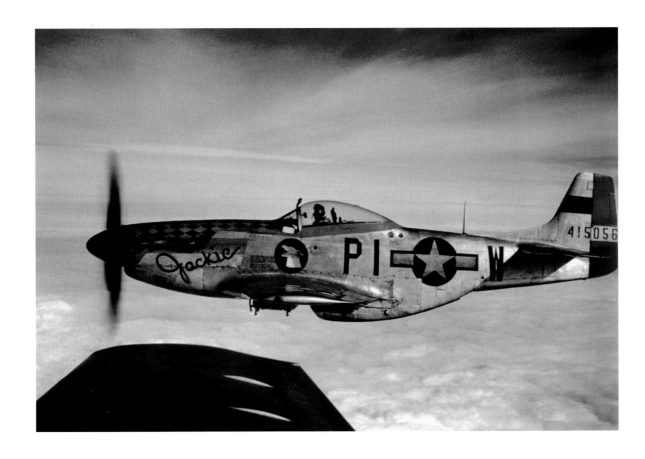

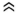

P-51D Mustang 44-15056 *Jackie* **of the 360th Fighter Squadron, 356th Fighter Group flown by Captain John W "Wild Bill" Crump, March 1945.** The painting on the fuselage commemorated 'Jeep', Crump's pet coyote brought over from America and who actually flew five missions with him before being accidentally run over and killed. The 356th FG gained a reputation as the 'hard luck' fighter group, suffering a higher loss-to-kill rate than any other unit in the Eighth Air Force – 201 aerial victories for the loss of 122 aircraft. Crump survived 77 escort and strafing missions, and went on to enjoy a long post-war career in aviation.

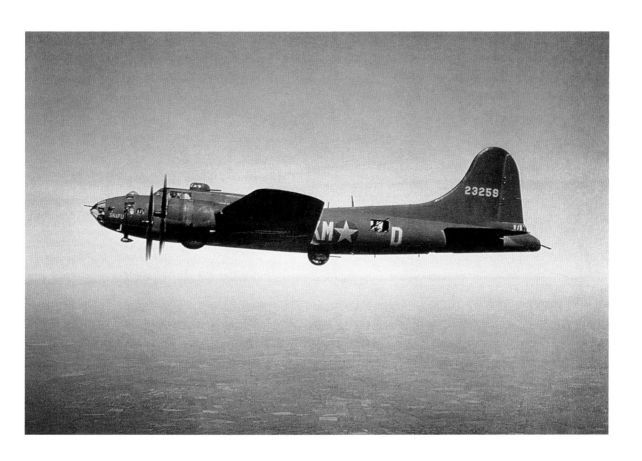

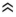

Boeing B-17F Flying Fortress 42-3259 'XM-D' *Snafu* **of the 332nd Bomb Squadron, 94th Bomb Group, spring 1943.** Representative of the Eighth Air Force's early Flying Fortresses, in July 1943 the aircraft was transferred to the 384th Bomb Group and renamed *Alabama Whirlwind*. The summer of 1943 was a desperate time for the bomber crews. The last week of July saw a sustained period of attacks against German targets – 'Blitz Week' – during which about 100 B-17s were shot down or damaged beyond repair (almost a third of the force at that time). This one survived the slaughter and flew 21 missions with the 384th before being retired from the front line in spring 1944.

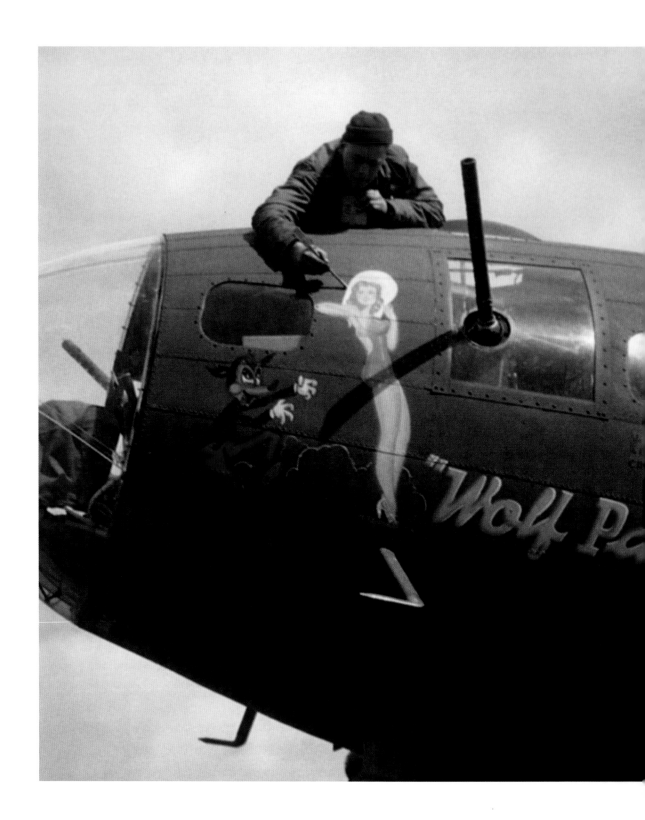

《

An airman adds the finishing touches to the nose art of newly delivered B-17F Flying Fortress 42-29723 at Bassingbourn in Cambridgeshire, May 1943. *Wolf Pack* was assigned to the 546th Bomb Squadron, 384th Bomb Group and went on to complete 18 combat missions. The B-17F's defensive 'cheek' guns on each side of the nose, used by the navigator and bombardier, were not best placed to deal with frontal attacks by enemy fighters, a weakness initially exploited by the Luftwaffe in the air battles over Germany.

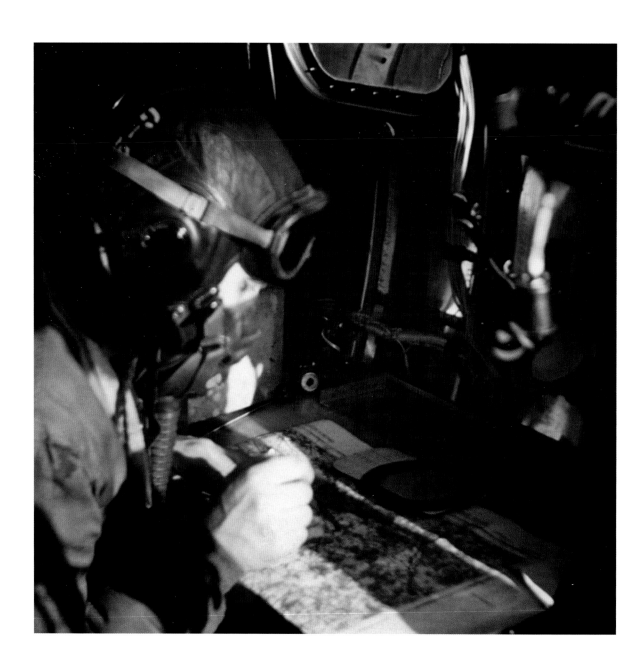

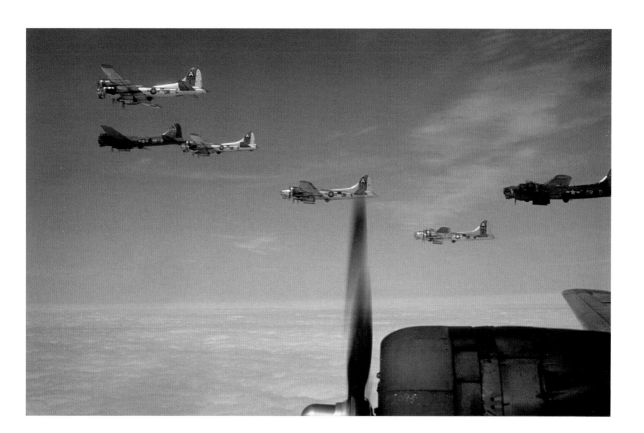

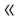

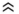

First Lieutenant Armando J Sinibaldo, a navigator with the 323rd Bomb Squadron, 91st Bomb Group, at his position in the nose of B-17G Flying Fortess 43-38379 'OR-O' *Margie.* In front of him are a map chart and an E-6B flight computer, or 'whizz wheel' – a circular slide rule used for navigation and bombing calculations. Sinibaldo safely completed his tour of 35 missions in November 1944 and returned to the United States.

'The Ragged Irregulars': B-17 Flying Fortresses of the 323rd Bomb Squadron, 91st Bomb Group, July 1944. Allied air superiority reduced the need for camouflage, so by 1944 aircraft were being delivered in natural metal finish, which also reduced production time. However, veteran aircraft could still be seen in their grey and olive drab paint. The USAAF experimented with various combat formations and at this stage of the war a bomb group would normally fly in three 12-aircraft squadron 'boxes', staggered from high to low. Groups would follow each other at four mile intervals.

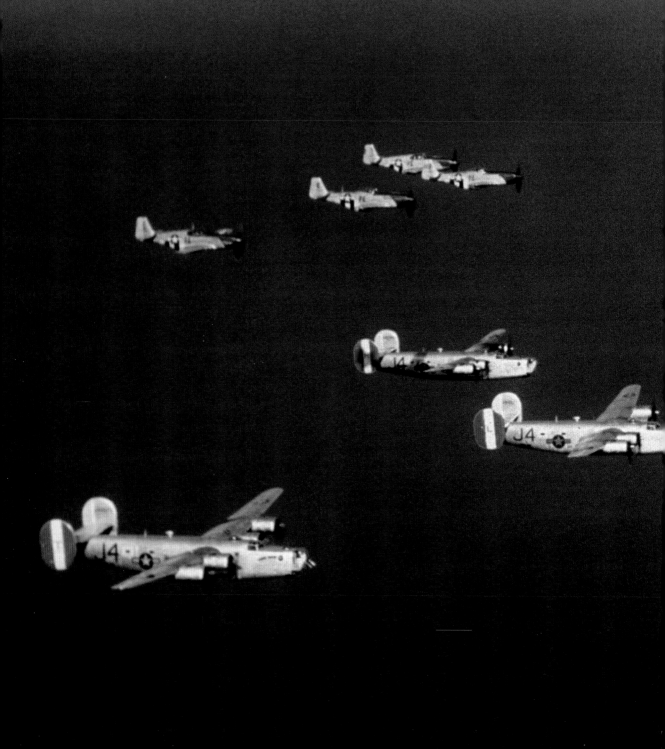

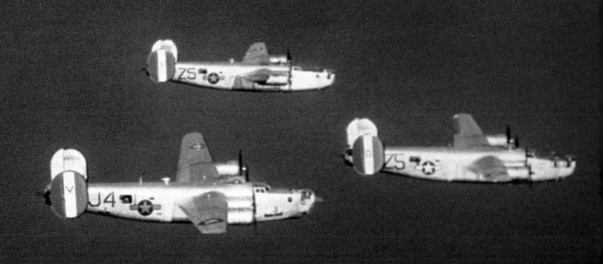

Consolidated B-24 Liberators of the 458th Bomb Group accompanied by P-51 Mustangs from the 352nd Fighter Group, 1944. While bomber crews naturally appreciated having their 'little friends' close by, it was more effective for the escorts to be out ahead when over enemy territory, ready to engage Luftwaffe fighters before they had time to form up and attack. At the start of 1944, US pilots were permitted to pursue enemy fighters at lower altitudes and strafe them on the ground, tactics which saw the Luftwaffe's

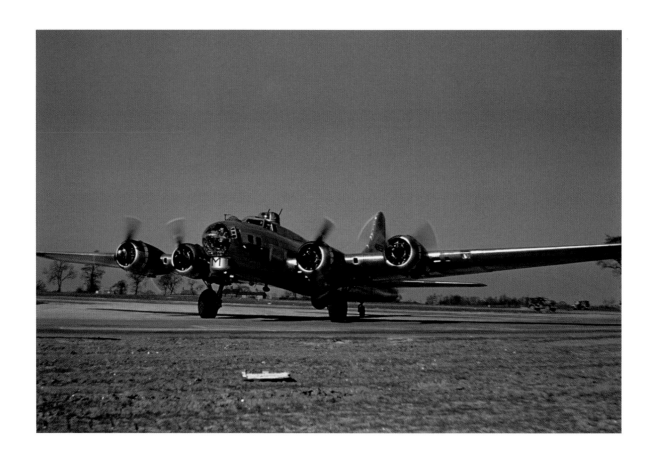

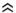

**A B-17G Flying Fortress of the 490th Bomb Group taxiing at Eye in Suffolk,
winter 1944–1945.** It wears the group's distinctive red identification bands on its
wings and tail. The 490th BG was one of five bomber groups which converted from
B-24 Liberators to B-17s in the summer and autumn of 1944 to exploit the better
flying qualities of the Boeing. Among other improvements, the B-17G featured a
twin-gun 'chin' turret to deter head-on attacks, although by this stage of the war fighter
opposition was much reduced. The 490th flew a total of 158 combat missions and
suffered the lowest rate of combat losses of any heavy-bomber unit in the Eighth.

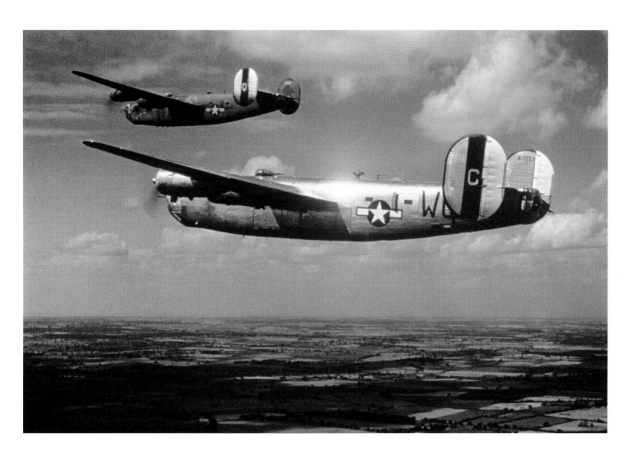

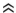

'The Flying Eightballs': B-24 Liberators of the 68th Bomb Squadron, 44th Bomb Group, based at Shipdham in Norfolk, summer 1944. The 44th BG was the first Eighth Air Force group to equip with Liberators. The B-24J in the foreground, 44-10553, was hit by flak returning from a raid on transport targets at Kaiserslautern in Germany on 28 December 1944. Second Lieutenant Thurston Van Dyke successfully belly-landed his aircraft at an Allied airfield in France and all ten men walked away unscathed. It was a bad day for the squadron as two other aircraft were lost – one shot down over the target and the other destroyed after it stalled and crashed after aborting the mission. From these two crews, seventeen men were killed.

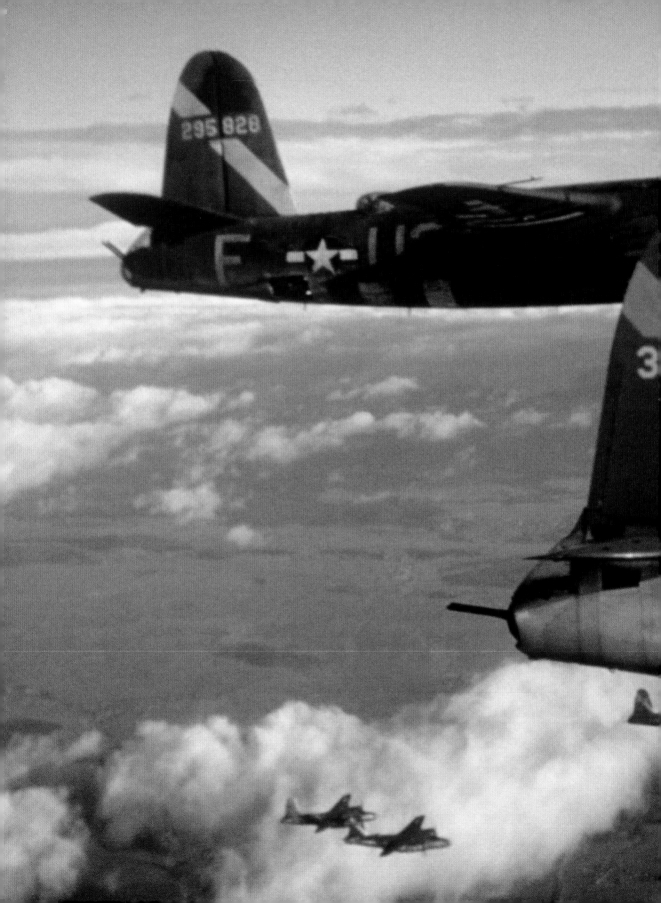

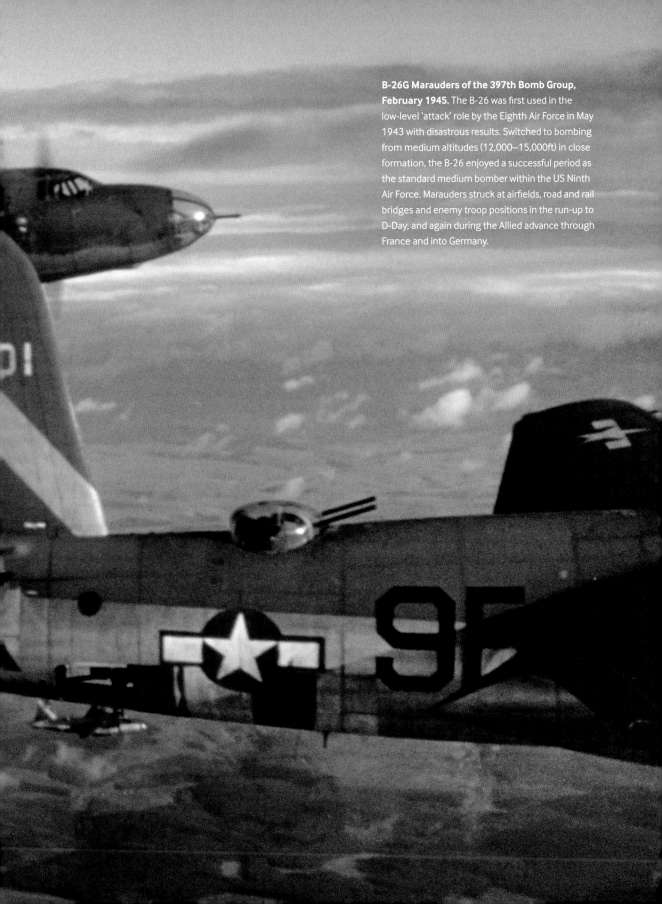

B-26G Marauders of the 397th Bomb Group, February 1945. The B-26 was first used in the low-level 'attack' role by the Eighth Air Force in May 1943 with disastrous results. Switched to bombing from medium altitudes (12,000–15,000ft) in close formation, the B-26 enjoyed a successful period as the standard medium bomber within the US Ninth Air Force. Marauders struck at airfields, road and rail bridges and enemy troop positions in the run-up to D-Day, and again during the Allied advance through France and into Germany.

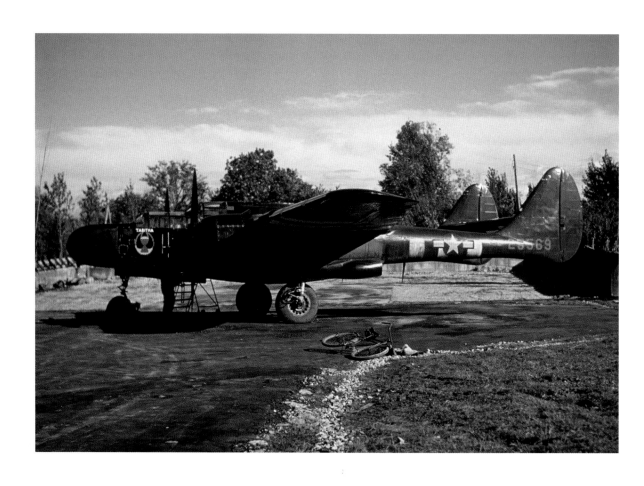

Northrop P-61A Black Widow 42-5569 *Tabitha* **of the 425th Night Fighter Squadron, 1944.** The big, twin-engine P-61 was the USAAF's first dedicated night-fighter, but did not enter service until after D-Day. Two squadrons operated with the US Ninth Air Force from bases in France and Belgium, from where they ranged deep into German territory. As well as preying on enemy aircraft, the Black Widows also operated in the 'intruder' role, attacking road and rail transport targets. *Tabitha* was written off after a landing accident on 27 October 1944, tragically killing pilot First Lieutenant Bruce Heflin and radar operator Flight Officer William B Broach.

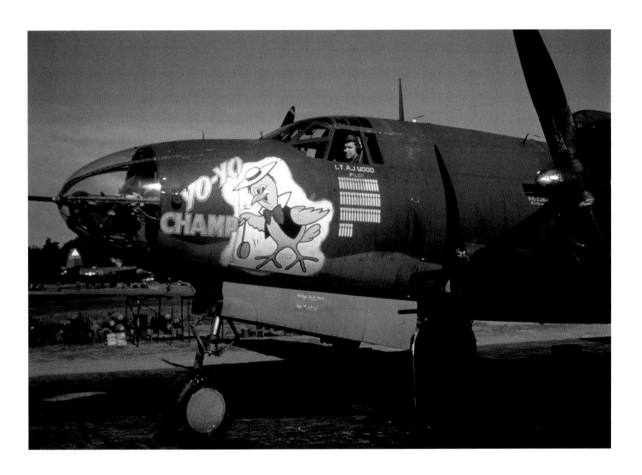

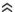

**First Lieutenant A J Wood of the 497th Bomb Squadron, 344th Bomb Group,
Ninth Air Force in the cockpit of his B-26B Marauder, 42-95987 '7I-S'**
Yo-Yo Champ, **at Stansted Mountfitchet in Essex, 1944.** The name was chosen
because yo-yos 'always come back' and the image of Chicken Little was apparently a
reference to the pilot's short, chubby physique and red hair. Severely damaged in July
1944, the aircraft was repaired and later transferred to the 17th BG, Twelfth Air Force.
It was shot down by Luftwaffe Me 262 jet fighters over Schwabmünchen in Bavaria
on 24 April 1945.

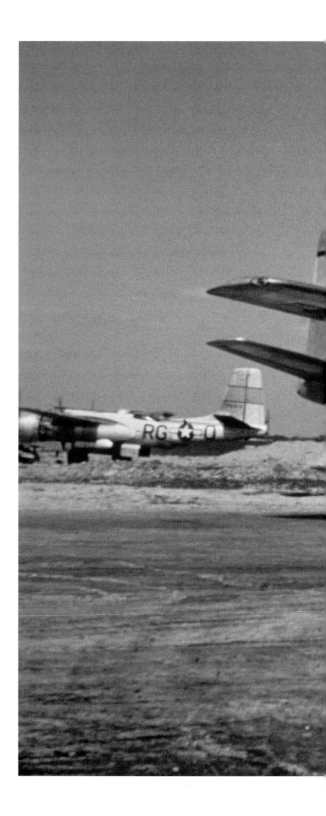

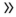 **Douglas A-26 Invaders of the 386th Bomb Group, Ninth Air Force at St Trond in Belgium, 1945.** Intended to replace the A-20 Havoc and B-26 Marauder, the A-26 first saw action over Europe in September 1944, and was equally at home on medium-level bombing or low-level attack missions. While the A-26B carried a battery of six or eight .50-inch machine guns in a solid nose, the A-26C 'lead ship' seen here had a glazed compartment for a bombardier and Norden bombsight. Five bomb groups in the Ninth had converted to the A-26 by the end of the war.

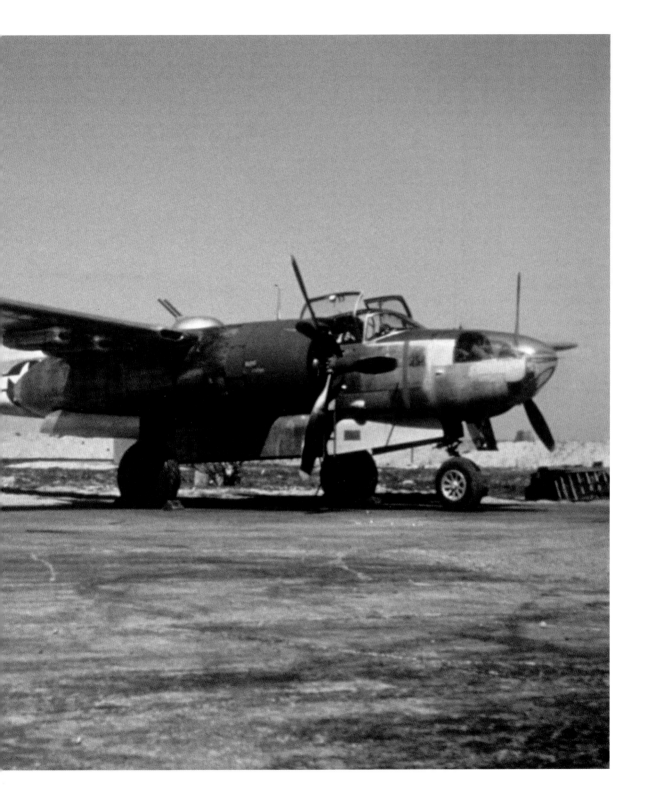

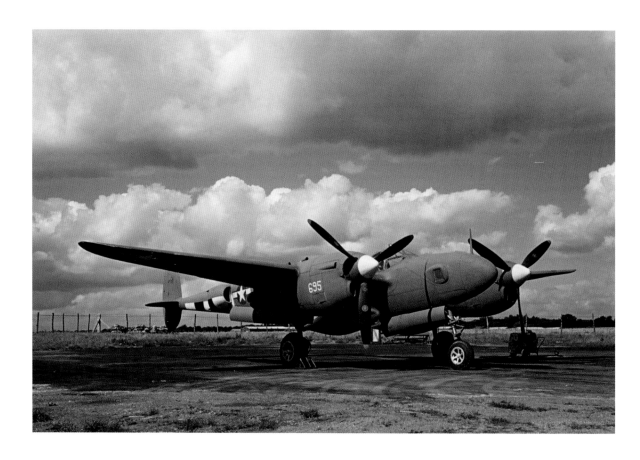

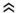

Lockheed F-5E Lightning of the 7th Photographic Reconnaissance Group at Mount Farm in Oxfordshire, August 1944. The 7th PRG served as the eyes of the Eighth Air Force, taking over 3 million photographs of Germany and occupied Europe and providing vital air intelligence for Allied commanders. Three of its four squadrons flew the F-5 — an unarmed, camera-equipped version of the P-38 Lightning fighter. This aircraft, 44-23695, was assigned to the 22nd Photographic Reconnaissance Squadron but was shot down by flak on 15 October 1944. Lieutenant Benton C Grayson bailed out and was picked up by Allied ground forces.

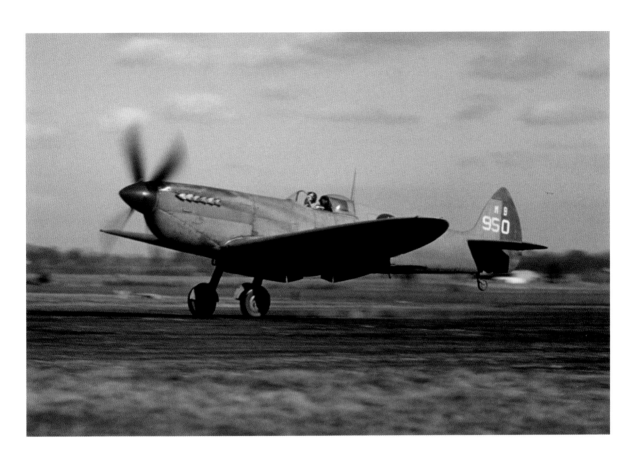

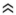

Spitfire PR Mk XI *Upstairs Maid* **of the 7th Photographic Reconnaissance**
Group touches down at Mount Farm, early 1945. While the rest of the 7th PRG
was equipped with the F-5, the 14th Photo Squadron flew specialist 'recce' Spitfires
supplied by the RAF. These could fly higher and faster than the Lightnings and so
were less vulnerable to interception by the Luftwaffe. MB950, seen here, wears the
red cowling stripe and blue spinner adopted in early 1945 as 7th PRG recognition
markings. The green rudder identified the 14th Squadron.

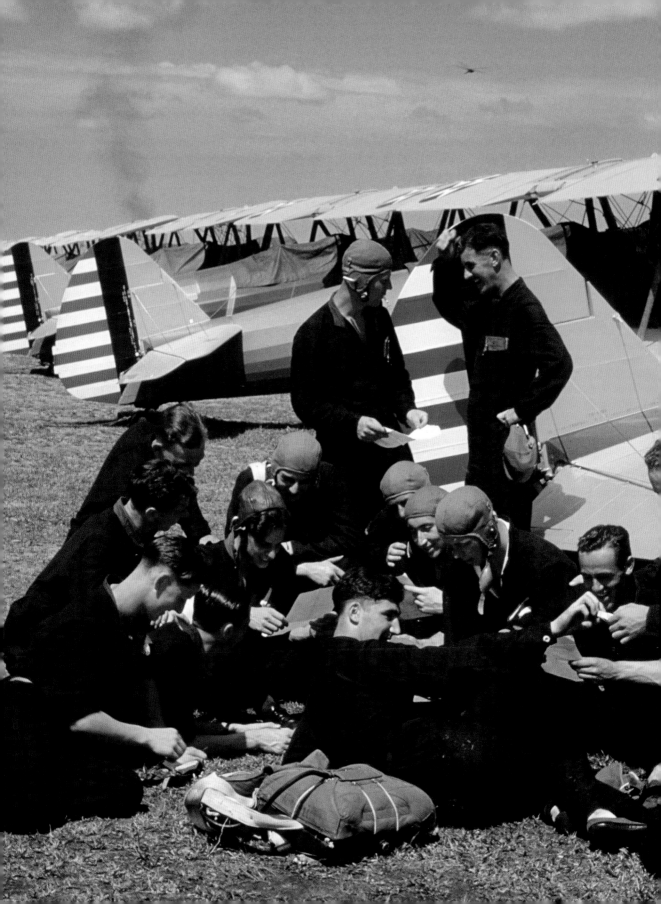

CHAPTER SIX

TRAINING AND TRANSPORT

The massive increase in the size and strength of the Allied air forces during the Second World War required a corresponding expansion of pilot and aircrew training. New schools and courses had to be created to prepare tens of thousands of the brightest young men to man the faster, larger and increasingly complex aircraft now coming into service. The training was carried out by a mixture of civilian and service instructors, some of the latter being pilots temporarily rested from operations. For these men in particular it could be a daunting task – some remarked that it was more dangerous than flying against the enemy.

RAF pilots typically passed through three key stages: elementary flying training, advanced training on more complex aircraft at a service flying training school and then operational training on the aircraft types they would be expected to fly. A host of other schools were created for non-pilot aircrew, covering air navigation, wireless telegraphy, bombing and gunnery. Later in the war, pilot instruction became longer and more complex with various advanced flying units and finishing schools. It would take between 18 months and 2 years (and at least 200 flying hours) before a pilot was squadron ready. All of this was administered by Flying Training Command, set up in 1940 alongside Technical Training Command, which was responsible for the equally vital task of turning out qualified ground staff.

Central to this expansion was the decision taken early on to base most pilot and aircrew training overseas. Britain itself was not best suited, with its changeable weather, the blackout and exposure to enemy air attack. Far better were the wider, clearer and safer skies of America, Canada and Britain's other dominions. It also freed up aerodromes in the UK for

operational training, when experience of European weather conditions was important, and other specialist instruction.

In 1940, the head of the United States Army Air Corps, General Henry 'Hap' Arnold, offered to train 4,000 RAF pilots alongside his own countrymen. This was gratefully accepted and became known as the 'Arnold Scheme'. Between June 1941 and December 1943, 7,885 trainee pilots were enrolled, of whom 4,412 qualified. The RAF set up training establishments of its own in America. Seven British Flying Training Schools were created, run by RAF personnel and involving US civilian instructors. A number of Fleet Air Arm pilots and RAF flying boat crews were trained by the US Navy. America also supplied one of the most important training aircraft used in the war, the North American AT-6 Texan, known to the British as the Harvard.

Important though American involvement was, by far the largest training effort was the British Commonwealth Air Training Plan, also known as the Empire Air Training Scheme, established in December 1939. Canada was the most suitable location and the main contributor to the scheme, producing 131,533 trained pilots and aircrew, but Australia, New Zealand and Southern Rhodesia were also involved. South Africa had its own programme, the Joint Air Training Scheme, which produced 33,347 aircrew. This vast production line was wound down in 1944, as an aircrew surplus built up and the war entered its closing phase.

Pilots in the USAAF went through a similar training regime to their RAF counterparts, passing through primary, basic and advanced levels, followed by transition training where they learned to fly operational aircraft. Finally, they were sent to unit training groups to be readied for specific theatres of war. A total of 193,440 US pilots graduated from advanced flying schools during the course of the war, alongside approximately 50,000 navigators, 45,000 bombardiers, 7,600 radar observers, 7,800 flight engineers and 297,000 gunners.

An essential but often overlooked aspect of the Allied air effort was transport, and the US would supply the bulk of aircraft for this purpose. The most important of these was the Douglas C-47 Skytrain, a military version of the DC-3 airliner, known to the British as the Dakota. It became the workhorse of the Allies' logistical effort, although there were never enough to go round. In fact, several Allied military operations, most notably the airborne assault at Arnhem in September 1944, were compromised as a

result. Other transport aircraft were converted from obsolete bombers. The RAF's Whitley and Stirling found new roles operating with British airborne forces as paratroop transports and glider tugs. The gliders themselves were flown by army pilots.

Another vital task was carried out by RAF Ferry Command, set up in July 1941. It had its origins in the Atlantic Ferry Service, a largely civilian organisation responsible for conveying aircraft from the United States to Britain. Over 9,000 aircraft made the crossing during the course of the war. In April 1943, Ferry Command was downgraded to No. 45 (Atlantic Transport) Group and incorporated into RAF Transport Command, which extended ferrying operations to all corners of the globe. The task of ferrying aircraft from manufacturers or between stations in Britain was mostly carried out by the civilian Air Transport Auxiliary, which became famous for its large number of female pilots.

(Previous Page)
RAF pilots in training with the Embry-Riddle Company at Carlstrom Field near Arcadia in Florida, 1941. Behind them are their colourfully marked Stearman PT-17s. Embry-Riddle was one of a number of private flying schools contracted by the US government to supply elementary pilot training. The cadets could not wear uniforms at this stage as America was still neutral. Some 18,000 RAF pilots were trained in the United States over the course of the war, either by the US Army Air Corps in the 'Arnold Scheme', or in seven British Flying Training Schools.

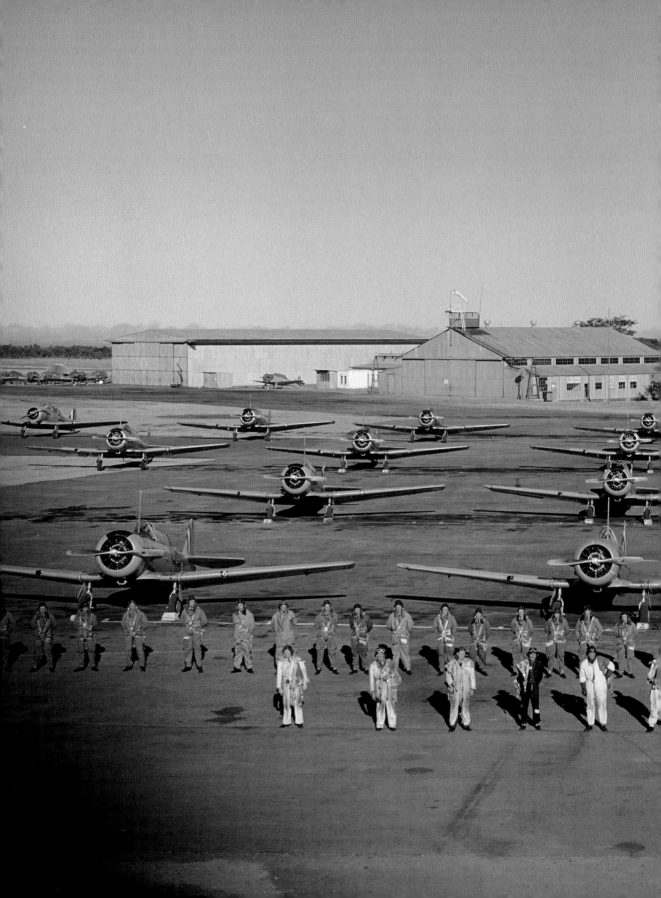

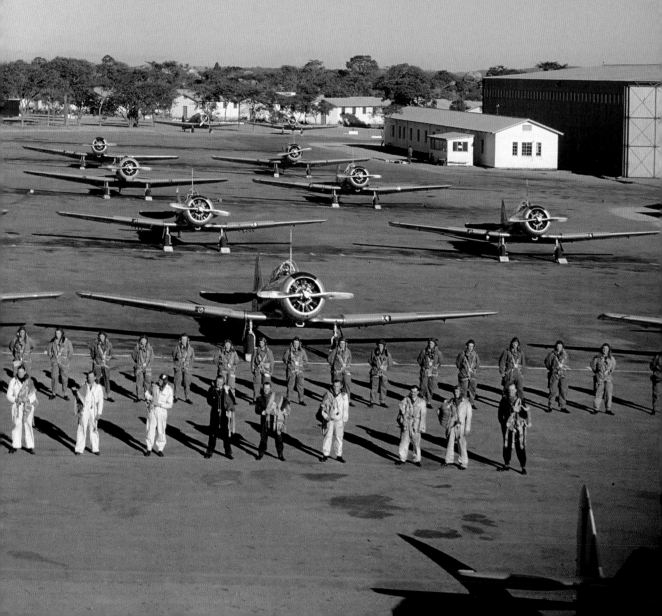

Instructors and pupils of No. 20 Service Flying Training School (SFTS) pose with their North American Harvard Mk IIAs at Cranbourne in Salisbury, Southern Rhodesia, 1943. An SFTS provided six weeks of advanced flying training, after which pilots gained their 'wings'. Southern Rhodesia's contribution to the Commonwealth Air Training Plan – known as the Rhodesian Air Training Group – was eight flying training schools, two bombing and gunnery schools and several other establishments. Of the 8,235 pilots and aircrew who went through the system, 446 were killed during their training.

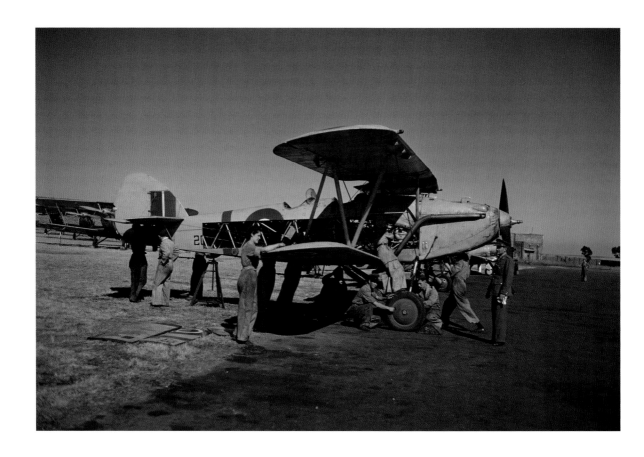

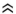

Male and female ground staff working on a Hawker Hart Trainer at No. 23 Air School at Waterkloof in Pretoria, South Africa, 1943. The Hart was a light day bomber introduced into RAF service in 1930, and from which fighter, naval, army cooperation and training variants were also developed. From 1937, Harts were phased out of service and relegated to a training role, with many being transferred to the SAAF. However, a handful were still on strength with frontline squadrons in Africa and India at the outbreak of war.

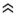

Aerial gunnery training with aircraft of No. 24 Bombing, Navigation and Gunnery School, based at Moffat in Southern Rhodesia, 1943. A trainee in the turret of an Airspeed Oxford Mk I attempts to hit a target drogue towed by a Fairey Battle. The Oxford had been designed specifically for RAF crew training requirements. The Battle, on the other hand, was an obsolete light bomber now pressed into second-line duties. 778 navigators and 1,590 air gunners were trained at Moffat, and the gunners course achieved the best results from any school in the Empire Air Training Scheme.

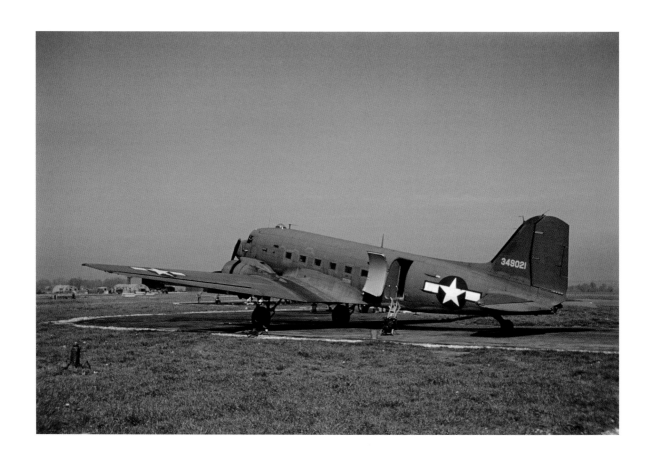

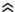

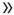

Douglas C-47B Skytrain 43-49021 at Mount Farm in Oxfordshire, August 1944. The C-47 was the most important Allied transport aircraft of the Second World War. It carried men and supplies, evacuated wounded, towed gliders and dropped paratroops. Many continued in service long after the war and some even saw action in later conflicts. This aircraft was one of 53 converted into AC-47D 'Spooky' gunships for service in the Vietnam War. It was shot down during a night fire mission with the USAF 4th Special Operations Squadron in September 1969.

C-47A Skytrain 43-15502 *Mary Co-Ed II* of the 74th Squadron, 434th Troop Carrier Group, US Ninth Air Force, 1944. On D-Day, the 434th TCG towed 84 gliders containing men of the 101st Airborne Division to Normandy in 2 operations. It was later involved in the airborne assault in the Netherlands, helped resupply US troops trapped at Bastogne during the Battle of the Bulge and took part in the Rhine crossing. Outside these major operations, the Ninth AF's 14 troop-carrier groups were used for routine supply and medical evacuation missions. On 24 April 1945, this aircraft was destroyed when it was hit by another C-47 in a landing accident at Bayreuth in Germany.

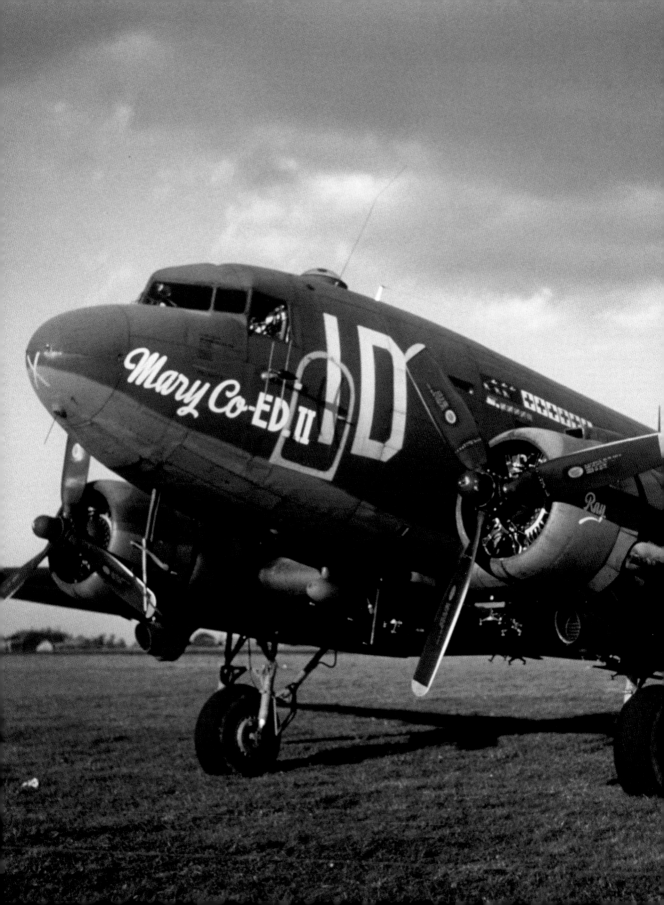

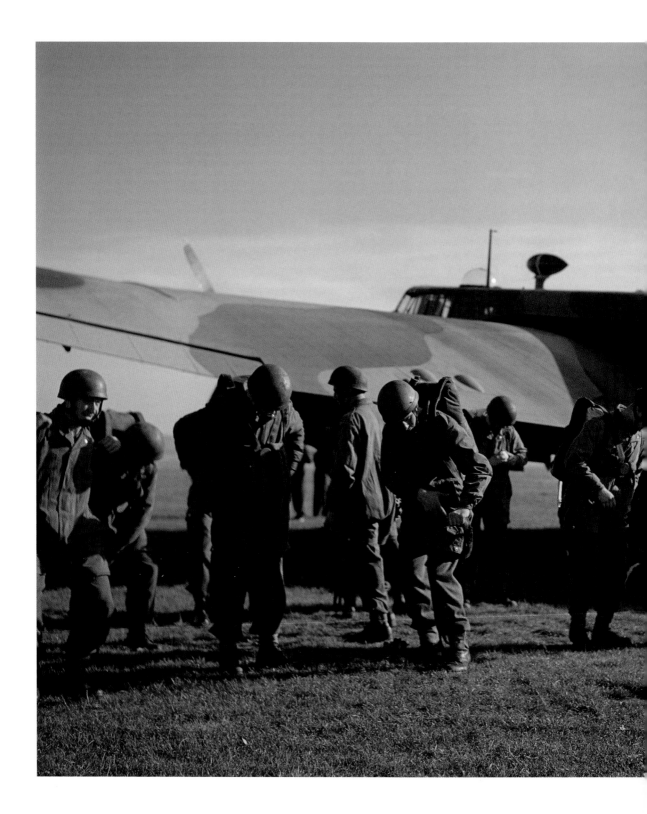

《

Paratroops check their equipment before boarding an Armstrong Whitworth Whitley Mk V of 295 Squadron at Netheravon in Wiltshire, October 1942. The Whitley was one of the RAF's early war bombers before being relegated to second-line duties. It played an important part in the development of Britain's airborne forces, being employed for parachute and glider training. In February 1942, Whitleys of 51 Squadron dropped paratroops for real during Operation 'Biting' — a successful combined operations raid to capture German radar equipment from a coastal site at Bruneval in northern France. Others were used by 'Special Duties' squadrons to drop agents into enemy-occupied Europe.

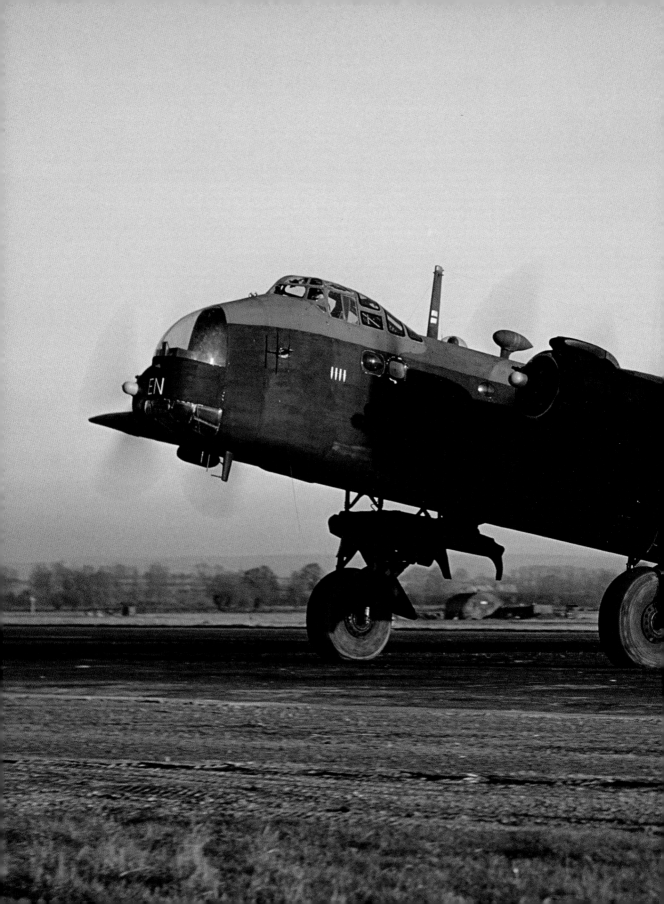

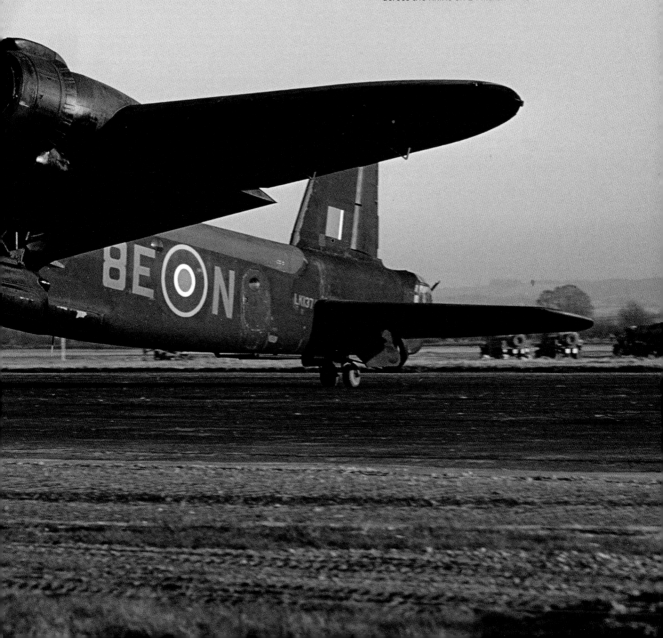

Short Stirling Mk IV LK137 '8E-N' of 295 Squadron.
Having been retired as a front-line bomber, the Stirling
was used successfully as a glider tug and paratroop
transport, playing an important role in the Normandy
and Arnhem airborne operations. The Mk IV was the
main transport variant and was also used to deliver
SOE (Special Operations Executive) agents and drop
arms and supplies to resistance groups in occupied
Europe. LK137 was shot down by flak during the
Allies' last great airborne assault of the war, Operation
'Varsity', when two airborne divisions were dropped
across the Rhine on 24 March 1945.

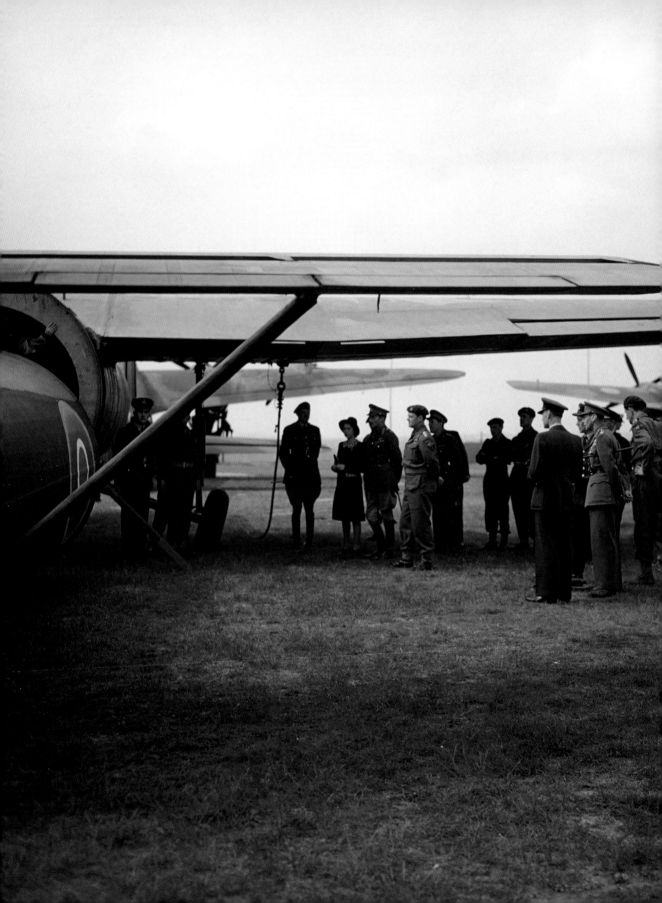

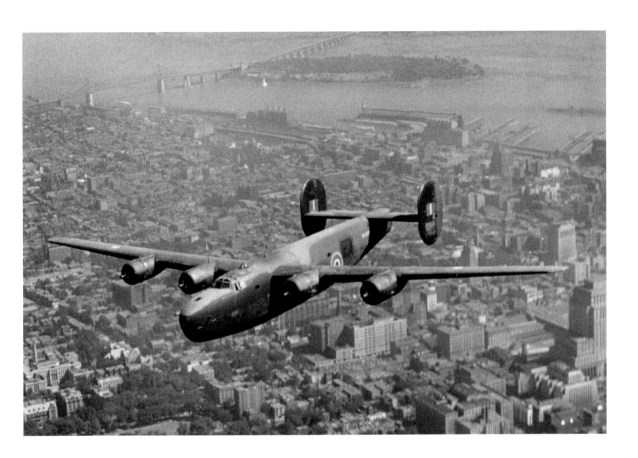

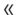

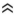

Senior officers accompany King George VI (right, with stick under his arm) and Princess Elizabeth as they inspect an Airspeed Horsa glider of 22nd Heavy Glider Conversion Unit during an airborne forces demonstration at Netheravon, May 1944. The Horsa was used to carry men and equipment of the British air landing brigades, and played an important role on D-Day and in subsequent airborne operations. It was also used by American forces. Its fuselage was designed to separate after landing to enable troops to quickly exit the aircraft. Stirling and Halifax glider tugs can be seen in the background.

Consolidated Liberator Mk II AL627 over Montreal, May 1944. Various versions of the B-24 Liberator served with the RAF in the bomber and maritime reconnaissance role, but this aircraft was one of several Mk IIs delivered as unarmed transports under the designation LB-30 and operated by the civilian British Overseas Airways Corporation. From May 1941, BOAC operated a return service for RAF Ferry Command, bringing back the crews who flew Canadian- and US-built aircraft across the Atlantic to Britain.

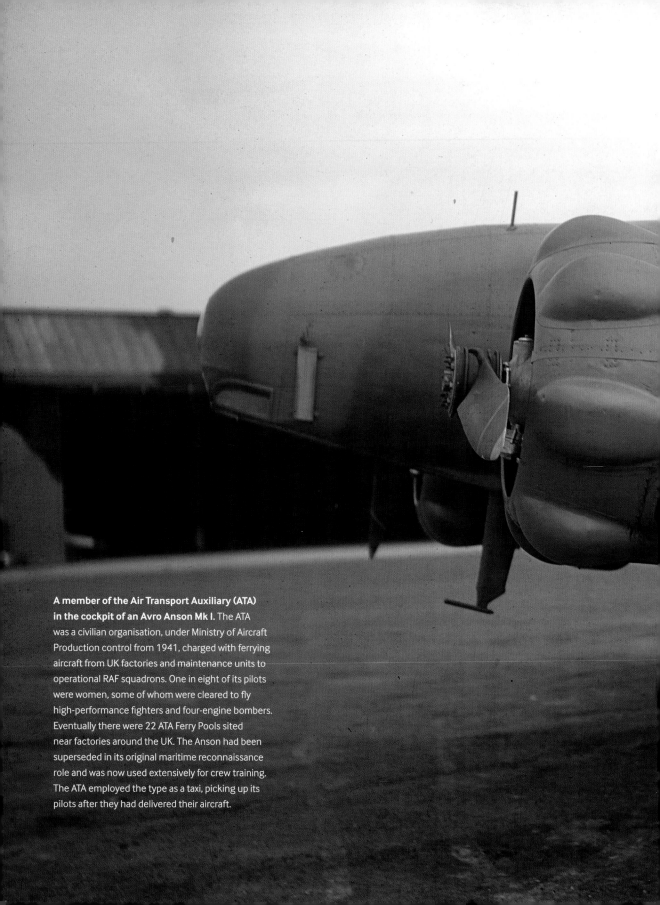

A member of the Air Transport Auxiliary (ATA) in the cockpit of an Avro Anson Mk I. The ATA was a civilian organisation, under Ministry of Aircraft Production control from 1941, charged with ferrying aircraft from UK factories and maintenance units to operational RAF squadrons. One in eight of its pilots were women, some of whom were cleared to fly high-performance fighters and four-engine bombers. Eventually there were 22 ATA Ferry Pools sited near factories around the UK. The Anson had been superseded in its original maritime reconnaissance role and was now used extensively for crew training. The ATA employed the type as a taxi, picking up its pilots after they had delivered their aircraft.

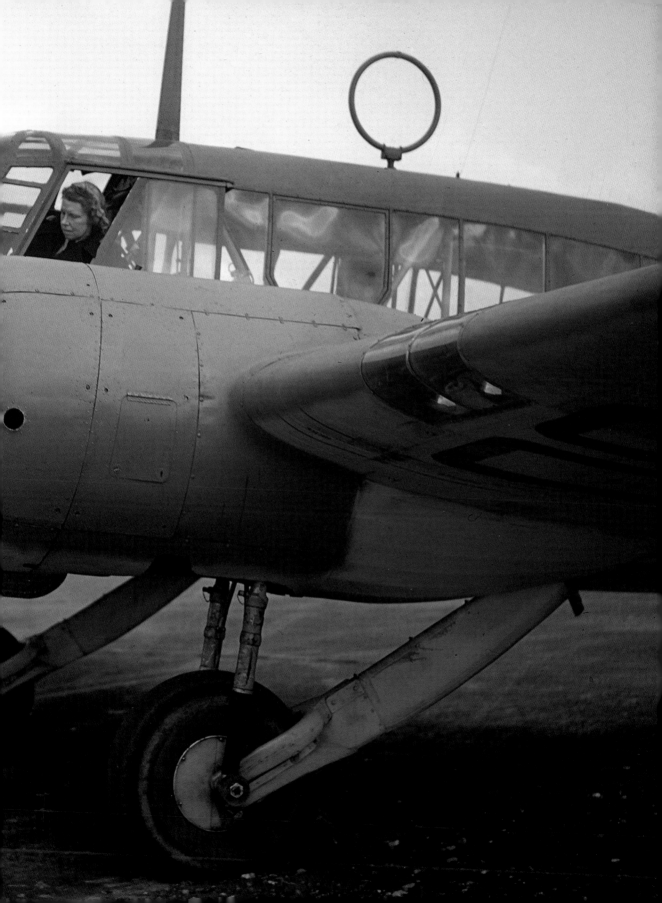

IMAGE LIST

All images © IWM unless otherwise stated. Every effort has been made to contact all copyright holders. The publishers will be glad to make good in future editions any errors or omissions brought to their attention.

INTRODUCTION
TR 188

FIGHTER BOYS
TR 22, COL 72, COL 186, COL 188, COL 191, TR 18, TR 516, TR 1091, TR 1090, COL 465, COL 750

BOMBER COMMAND
COL 205, FRE 16002, COL 185, TR 19, TR 37, TR 195, TR 197, COL 194, TR 1795, FRE 6153, FRE 6155

MEDITERRANEAN AIR WAR
TR 850, TR 975, TR 856, TR 866, TR 1019, TR 872, TR 1063, FRE 7563, FRE 8701, TR 1537, FRE 14185, FRE 14187, TR 2805

MARITIME STRIKE
TR 1084, COL 183, TR 108, TR 39, COL 187, COL 182, TR 1276, TR 1273, TR 287, TR 1812

USAAF OVER THE REICH
FRE 7212, FRE 5604, FRE 5545, FRE 5357, FRE 2807, FRE 6075, FRE 5821, FRE 5950, FRE 5748, FRE 5735, FRE 6714, FRE 6835, FRE 5472, FRE 7357, FRE 7460, FRE 7133, FRE 7300, COL 408, FRE 5381

TRAINING AND TRANSPORT
TR 89, TR 1263, TR 1253, TR 1258, COL 381, FRE 7452, TR 176, COL 364, TR 1837, TR 2493, TR 34

ACKNOWLEDGEMENTS

I would like to thank the following colleagues for their work in the creation of this book: David Tibbs for steering the project and the IWM Publishing team for their support, Georgia Davies for the design, Matthew Pentlow for coordinating image production, Curator Emily Charles for historical checks and advice and especially Emma Campbell and Dean Moore for their skill and expertise in producing faithfully accurate digital versions of the original images.